Artists At Work

Polymer Clay Comes of Age

Pierrette Brown Ashcroft

Lindly Haunani

Flower Valley Press
Rockville, Maryland

Caned Earrings. *Steven Ford* and *David Forlano.* 1 inch x 1.25 inches.

Published by:
Flower Valley Press, Inc.
7851-C Beechcraft Avenue
Gaithersburg, MD 20879
U.S.A.

Printed in Hong Kong

Photograph credit: p. 19—Illustration by Françoise Durham-Moulin, from *Jill and the Jogero* by Richard Thompson, photograph by Tim Swanky appears courtesy Annick Press Ltd., Toronto, Ontario. Published 1992.

All photographs not otherwise credited were taken by Allen Bress.

Ashcroft, Pierrette Brown.
 Artists at Work: Polymer Clay Comes of Age
 1. Crafts - United States - History - 20th century. I. Haunani, Lindly. II. Title.
ISBN # 1-886388-02-4

10 9 8 7 6 5 4 3 2 1

Front cover: Necklace by Pier Voulkos.

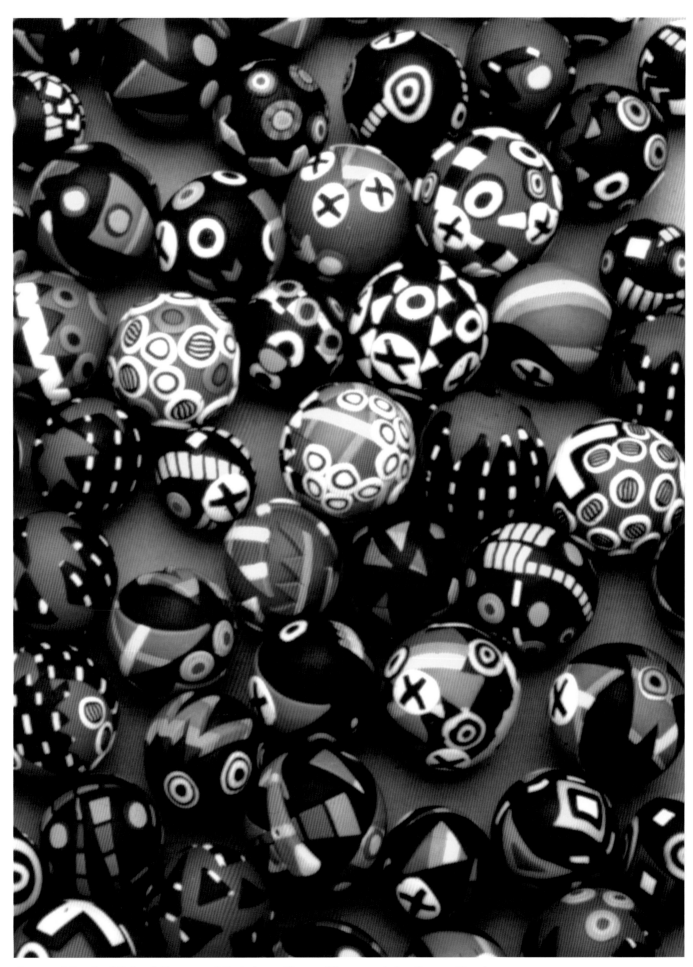

Assorted Beads. *Michael Grove and Ruth Anne Grove.* (Photograph by George Post.)

Contents

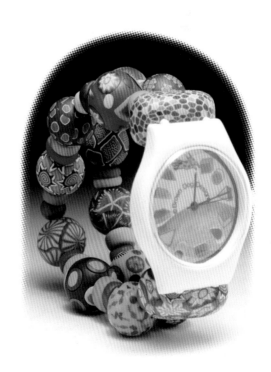

Watch. *Pierrette Brown Ashcroft.*

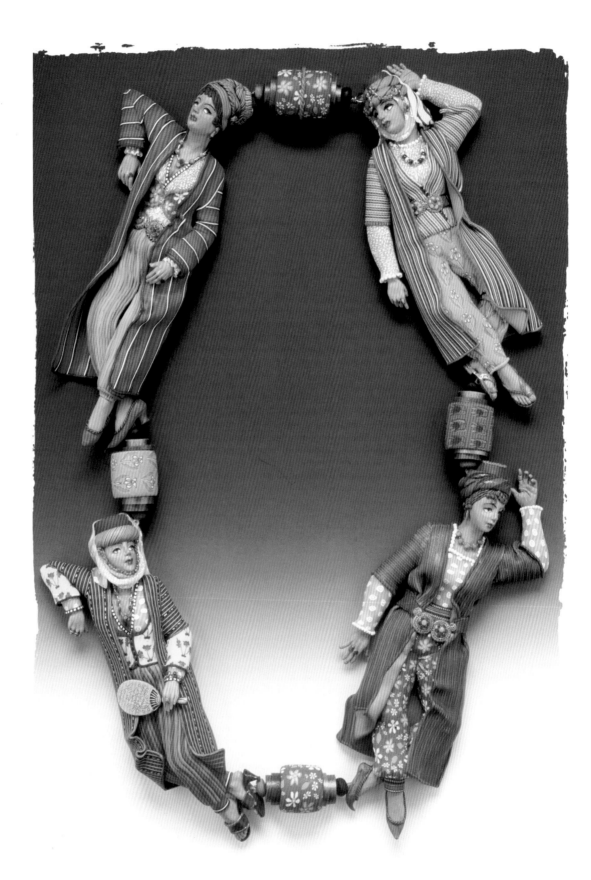

Those Harem Nights Necklace. *Kathleen Dustin.* Kathleen combined millefiori, modeling, and onlay techniques to create each figure. Necklace: 27 in. long, each figure 6.5 in. (Photograph by George Post.)

Foreword

AT THE END of a wonderful evening with a gathering of polymer-clay artists and friends, I had the pleasure of looking at some of the transparencies for this book. How exciting it was to see just how this incredible medium is evolving! As we held each sheet of transparencies up to the light, the excitement level kept rising. We talked about Pier Voulkos and her "sowing of the seeds" for much of what we were seeing. We talked about Maureen Carlson, Tory Hughes, and many others, whose independent tracks now converge into a tremendously diverse group of artists. Their love of this material and their innovative use of it will be apparent in the pages that follow.

Only a few years have passed since the publication of *The New Clay* and the developments in the world of polymer clay are still moving very rapidly. The use of polymer clay is growing across the country and beyond, thanks in part to the formation of the National Polymer Clay Guild. Credit is also due to the many generous people who are teaching and sharing their knowledge about polymer clay within their networks. People are finding novel and wonderful ways to incorporate it into their artistic visions, and also, are just having a lot of fun.

The artists represented in this book come from many different backgrounds and disciplines. They are pushing, stretching, and redefining the boundaries of this remarkable medium. All of us who love poly-

Masks. *Nan Roche.* Nan combined polymer clay with metal leaf, glitter, metal fibers, and sticks. Each 6.25 in. x 9 in.

mer clay experience wave after wave of amazement each time we see new work, because there is such variety. We all look forward with excitement to the future of this medium, which has come of age in the 1990s.

The immediacy of the material, the need for just a few tools, and the minimal technical knowledge required to start working with

polymer clay, allow free rein of artistic expression. The continued rapid increase in the number of artists working in polymer clay seems to suggest that interest in the material is here to stay. Many shops and galleries around the country now feature polymer-clay work with much success. The increasing presence of items made of polymer clay at craft shows expands the public awareness of

this fascinating material. I hope that polymer clay will continue as a new medium for artists and that we will see it become part of art curriculums in high schools and colleges as well as art schools themselves. As interest increases, we can look forward to even more new products from the manufacturers to supplement our already diverse and wonderful repertoire of polymer clay.

I want to thank Lindly Haunani and Pierrette Brown Ashcroft for their presentation of some of the best work in polymer clay to date. Both were instrumental in the formation of the National Polymer Clay Guild and have been at the heart of developments in this new field. The splendid newsletter they produced for three years helped to unite the field. Thank you both for this wonderful book and for providing fuel for the fire.

Whether you are enjoying this book as a visual feast for pure pleasure or as a source for inspiration in your own work, I know you will share my amazement at the diversity of work shown herein. I hope there will be many more presentations of polymer-clay work of this high caliber in the years ahead. Enjoy!

Nan Roche

Detail of Neo-Squash Blossom Necklace. *Michael Grove and Ruth Anne Grove.* This necklace has a unique magnetic clasp embedded in a bead. 22 in. long. (Photograph by George Post.)

Detail of Square and Diamond Beads (page 45). *Laura Liska Oakes.* (Photography by Laura Liska Oakes.)

Preface

THIS BOOK IS the culmination of a friendly working relationship between us—Pierrette Brown Ashcroft and Lindly Haunani. Soon after meeting in 1990, we worked together for three years to produce the *POLYinforMER*, the National Polymer Clay Guild's newsletter. That experience gave us an opportunity to meet many polymer-clay artists and become acquainted with their work.

One artist we were fortunate to meet, Nan Roche, author of *The New Clay,* suggested we write this book because of our experience with the Guild's newsletter. She was kind enough to introduce us to Seymour and Helene Bress from Flower Valley Press. After several conversations with them and with encouragement from Nan, we committed ourselves to the project. *The New Clay,* the first compre-

hensive, technical book on polymer clay, was so successful that the desire and need for more books on the subject was clear to us. Since Nan's book concentrated on the techniques used with polymer clay, we decided to focus on the artists and their artwork.

Selecting the work included in this book was not an easy task. Using a variety of criteria, we made the

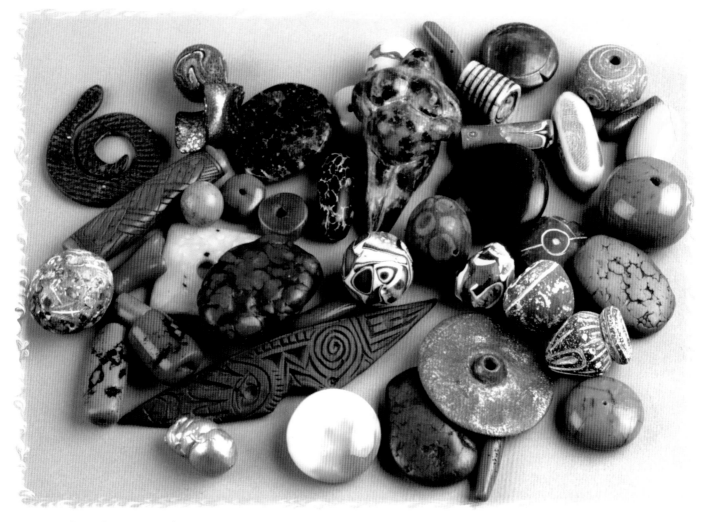

Assorted Beads. *Tory Hughes.*

preliminary selections by reviewing more than a thousand slides submitted by over 150 artists. We were looking for unique and innovative work displaying high-quality design and construction. In addition, we wanted to include artists experimenting with different approaches, and have tried to present a diverse representation of polymer-clay work.

Despite our efforts to bring together the work of a variety of artists and focus on their shared passion for polymer clay, we realize that we were able to see only a small segment of all the polymer-clay work being done. Nevertheless, the artists whose work is presented here display a vast array of techniques and approaches to working with polymer clay. In addition, profiles of the artists (arranged in alphabetical order) describe "why," and sometimes "how," they create their work. We compiled these profiles using materials the artists sent to us, a survey they answered, and by making many telephone calls. Along with the profiles, we have included the questions we asked the artists about their working methods, their tools, and their studios. Their answers, grouped by question, appear throughout the book. We hope they will provide additional insight about how these artists work.

Writing this book gave us an opportunity to truly enjoy, first hand, the trials, tribulations, and joys of a collaborative project. Many individuals contributed to its creation and completion. To them we extend our sincerest thanks. So many generous artists sent materials to be considered for inclusion, we would like to express our heartfelt appreciation to all of them; they made this book possible. Next, a grateful acknowledgment and thanks to Seymour and Helene Bress, our publishers,

Double Harry Earrings with Stand. *Pier Voulkos.* Sometimes, making the jewelry is not enough for Pier and she uses polymer clay to make displays for her necklaces and earrings. Earrings: 2.5 in. long. (Photograph by George Post.)

whose encouragement, understanding, and gentle nudging made this project a reality. Additionally, a big thank you to Allen Bress who so expertly photographed most of the work. And last, but hardly least, we extend a special thanks to many others who gave us expertise, time, and support; Nanette Bevan, Steve Brown, Kate Coventry, Amy Forman, Beverly-Rose Grover, Ted Grover, G. Thorton Hunter, Peter Mitchell, Nan Roche, Ruth Schimel, Tina Seashore, Sue Taylor, Bruce Thiel, and Libby Thiel.

Detail of The Zodiac Canes. *Kathleen Amt.* These canes were used to construct the game featured on page 5.

Introduction

THIS BOOK IS dedicated to the celebration of polymer clay as a remarkable new artform. Polymer clay is a form of polyvinyl chloride, one of the most common plastics in use today. It is available in brilliant colors, in metallics, and in varying degrees of translucency. You can mix colors to create your own color palette. The lightweight nature of this material makes it ideal for jewelry, but it is also durable, making it a suitable medium for vessels, dolls, or sculptures—objects that need strength. Before polymer clay is fired, it is pliable at room temperature, and can be sculpted, modeled, and molded. Exposure to low heat (212-270°F) hardens it, at which point it can be carved, drilled, sanded, buffed, and painted. Shrinkage is imperceptible and the colors change very little after firing. As a versatile medium, polymer clay is limited only by the artist's imagination.

The fact that polymer clay is easy to work, and is responsive, allows even the novice an opportunity to experiment and create. Working with it requires only simple tools, minimal expense, and the willingness to experiment. Unlike most mediums, polymer clay has as yet no strong tradition that dictates a particular style. Many techniques used with polymer clay have their origins in other mediums such as glasswork, ceramics, beadmaking, and printmaking.

Millefiori Canes. *Liz Mitchell.* Liz has used a simple wrapped cane to build these mosaic canes.

Dollmakers and miniaturists have used polymer clay for over 30 years. Around 1987 it became more widely used as an art medium, when many artists, craftpersons, and hobbyists began working with it for a variety of reasons. Some switched from other disciplines to polymer clay for its quick results and because of the low costs involved. Its bold and bright colors lured others to try their hand. The realization that polymer clay is an alternative to glass for canemaking appeals to artists who find the patterning possibilities alluring. It seems to attract both artists and non-artists since a wide array of techniques can be used with it.

The surge of polymer-clay use in the late 1980s was primarily because of an interest in millefiori canework and jewelry making, although there are exceptions. As artists became proficient in cane making, many began to experiment and to try new working methods and new approaches. An interesting aspect of this experimentation is that so many techniques and ideas seemed to appear simultaneously in different parts of this country and around the world. In the early 1990s, several artists started using polymer clay to make mosaics. Some made canes that resembled mosaics and others used polymer-clay "tiles" to assemble their mosaics. Around the same time, many artists started exploring molding techniques. This concurrent emergence of similar techniques may be attributed to the fact that many artists are adapting techniques used in other mediums for use with polymer clay.

Artists featured in this book come from diverse backgrounds: some were established artists in other media while others did not previously consider themselves artists. What they all share is an openness and a willingness to exchange ideas and techniques. That openness is one aspect that fueled polymer clay's popularity. The more people there are working with polymer clay, the more ideas there are to share and try.

Much credit for popularizing polymer clay goes to Nan Roche, author of *The New Clay*. Through

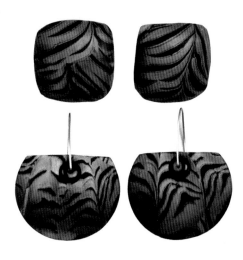

Feline Earrings. *Shellie Brooks and Doug Quade.* Shellie made a plaster mold to aid in the creation of her pillow earrings (top). She laminated cane slices onto a sheet of polymer clay, then pressed it into the mold, and attached an earring backing before firing. The lightweight hollow construction enhances their wearability. Top: 1 in. x 1 in. x .5 in., lower: 2 in. x 1.5 in.

Summer Rainbowl. *Tory Hughes.* 8 in. diameter.

her book, she encouraged further experimentation and, as a result, several changes have taken place. Many artists continue to push beyond the perceived boundaries of polymer clay. They are experimenting with larger-scale projects, combining polymer clay with other materials, and taking polymer-clay work in new directions while creating a fascinating variety of work. Artists such as Lynne Sward have expanded on the use of image transfers with polymer clay to include full-color laser copies. Michele Fanner has taught her puzzle-like, cane-construction method to many. Now she and other artists create detail otherwise difficult to achieve using the rod-and-slab approach to cane making discussed in *The New Clay*. Tory Hughes has refined imitative techniques with polymer clay and continues to experiment with them. What is important, *The New Clay* has introduced thousands of "non-artists" to the material, providing them with a new creative outlet.

Appreciation is also due to Pier Voulkos who is directly and indirectly responsible for exposing many artists to polymer clay. Her high level of technical achievement, attention to detail, and exceptional designs have inspired several artists in this book. In the mid 1980s, Helen Banes, founding president of the Washington, D.C. Bead Society, purchased one of Pier's necklaces in New York City. Among those who saw that necklace were Jamey Allen (in Los Angeles, California) and Kathleen Dustin (in Alexandria, Virginia). Jeni Breen, who danced in the same troupe as Pier in New York, was so excited by another of Pier's necklaces, she showed it to her sister Martha (in Berkeley, California), who in turn showed it to Ruth Anne and Michael Grove. Later, the Breens' mother encouraged Steven Ford and David Forlano to try their hand at the

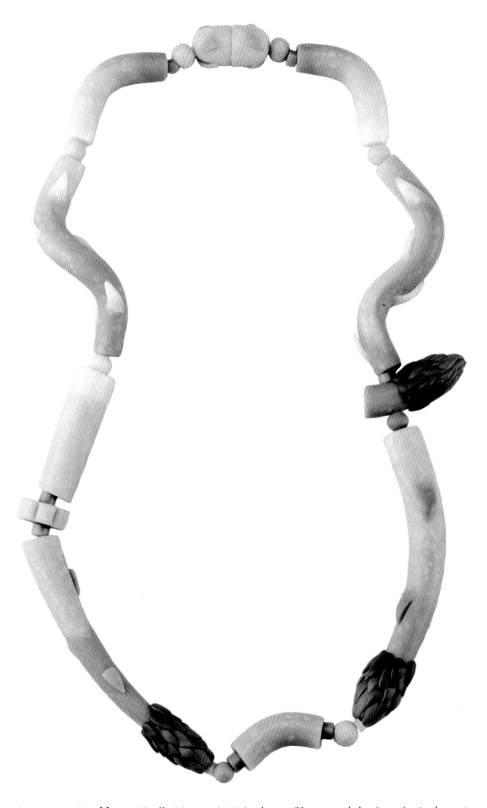

Asparagus Necklace. *Lindly Haunani.* 27 in. long. (Photograph by Jerry L. Anthony.)

medium. When many of these artists began to teach, Pier's influence increased and spread dramatically.

Of course, many artists began working with polymer clay independently, and they were surprised to learn they were not alone. Michele Fanner started making polymer-clay buttons for her hand-knit garments, but did not realize the medium's potential until a friend introduced her to the National Polymer Clay Guild. There were others outside the United States who felt isolated working in the medium until the publication of *The New Clay*. In South Africa, Rudi and Milene Sennett expanded on Milene's research of ancient glass technology and adapted these techniques for use with polymer clay. Françoise Durham-Moulin worked with it for many years in Canada, striving to have her work in the medium taken seriously. For all of them, it was rewarding to discover so many other artists working with this "new medium."

There are a few artists in this book who have worked with polymer clay for many years, but most started after 1987. Tory Hughes has been working extensively with it for over 20 years, experimenting, while gaining great familiarity with the material. She now passes on her knowledge and discoveries through the workshops, lectures she presents around the country, and how-to videos. In 1979, when Maureen Carlson started working in the medium, the only information she had on the material was from miniaturists. Since then, she has made hundreds of dolls and taught many others.

There are numerous factors helping to promote polymer clay: museum and gallery exhibits, workshops, lectures, articles and

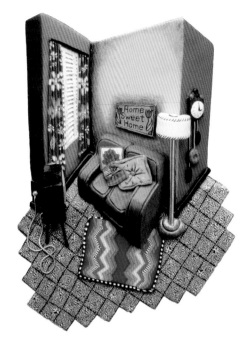

Home Sweet Home. *Kathleen Dustin.* 3.63 in. x 2.5 in. (Photograph by George Post.)

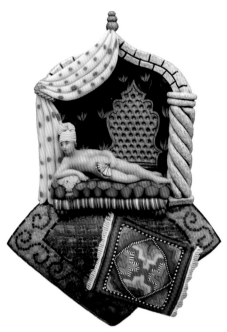

Odalisque Pin. *Kathleen Dustin.* 3.63 in. x 2.75 in. (Photograph by George Post.)

books, and the emergence of the National Polymer Clay Guild. Many galleries around the country host polymer-clay shows and museums are beginning to add polymer clay to their collections. Kathleen Amt's polymer-clay books are in the collections of the National Art Library of the Victoria and Albert Museum in London, the Rare Book Collection of The National Gallery of Art, and the Women's Museum in Washington, D.C. Michael and Ruth Anne Grove have their work in the collection of the Cooper-Hewitt Museum in New York City. The National Polymer Clay Guild has published a newsletter and promoted national touring gallery shows since its formation in 1990. *Ornament* magazine and other publications have featured the work of many of these artists. All these factors have influenced both the popularity and acceptance of the medium.

The rise in polymer clay's popularity leads one to wonder whether

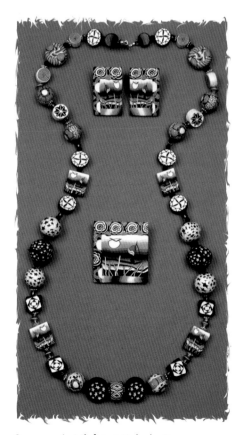

Summer's Night. *Michele Fanner.* Necklace: 32 in. long, earrings: 1.5 in. x 2 in., pin: 3 in. x 3 in.

it is a fad, or if it will endure and continue to grow in greater use as an art medium. Some segments of our society are open to new ideas and change, while other segments relate best to the established definitions of "art." Among the latter, polymer clay may always be dismissed because it is a "plastic." The important factor should be what artists create and have to say, not the materials they choose to use. Perhaps the artwork presented here will help overcome prejudices associated with polymer clay and establish it as a bona fide aesthetic medium.

We hope the work featured in this book in over 170 color photographs, will provide inspiration for others. Although the temptation may exist to borrow some ideas, one must respect the artwork as such, and not use it as a blueprint for other or future work. Setting aside the legal issues of copyright and plagiarism, one should have the courage to develop one's own style and ideas. Let the romance of creation be a gratifying experience and let the work of others serve as a stimulus for new ideas and designs. The creative process is experienced most richly when risks are taken, not when the work of someone else is imitated.

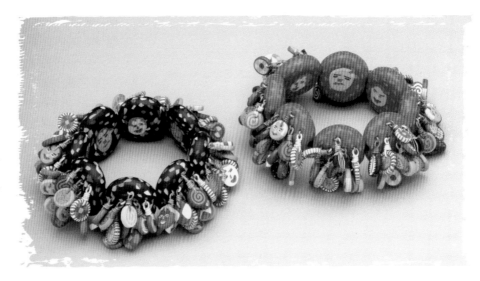

Harry Bracelets. *Pier Voulkos.* These polymer-clay bracelets were originally called "Hairy" bracelets because of their fuzzy or shaggy appearance. When a gallery misspelled the title, Pier decided she preferred the new name, "Harry" bracelets. (Photograph by George Post.)

Detail of Mosaic Picture Frame. *Steven Ford and David Forlano.* From page 26.

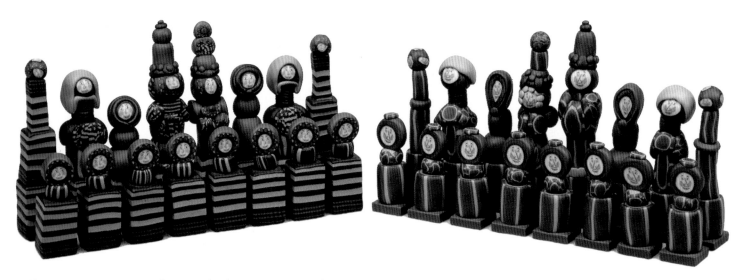

Chess Set. *Maureen Carlson.* Each chess piece is made
entirely of polymer clay. Between 1.5 in. and 4 in.

The Artists

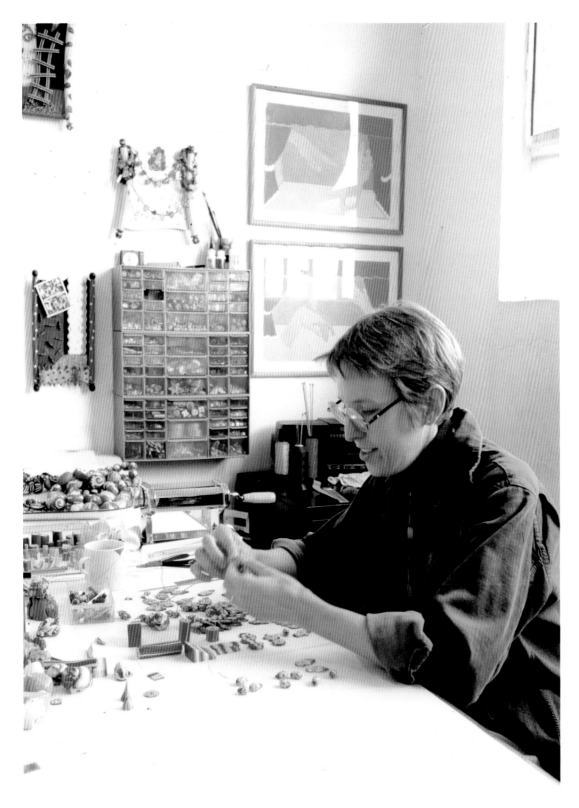

Pier Voulkos working in her studio. (Photograph by Vince Riggio.)

Aida Pin. This polymer-clay pin features Jamey's conception of an elegant Nubian princess. Constructing the braided hair was a new challenge for him. He created the scalloped border with slices of a striped cane that he combed before applying it to the pin. 1.88 in. x 1.75 in.

 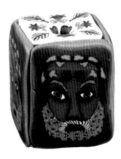

Satyr and Maenad Beads. These polymer-clay beads are made with four dominant canes derived from Roman period face and floral images. Each .75 in. x .44 in.

Jamey D. Allen
Santa Rosa, California

"Don't overdo. Economy of manipulation is important. Slow down. Think."

JAMEY STARTED working at a bead shop in 1972, a time when there was a tremendous increase in the number of beads imported into the United States from Africa. Jamey worked with such a variety of beads that he began to theorize, simply by looking at them, how various beads were made.

In 1986, in hopes of better understanding ancient glass technology and of proving or disproving his own theories, Jamey set out to reproduce ancient glass beads with polymer clay. Two notable beadmaking techniques he first recreated are Persian folded beads and Phoenician head beads. A conversation between Jamey and Robert Liu, editor of *Ornament* magazine, concerning the possibility of reproducing face canes in polymer clay, prompted a new experiment. When Jamey replicated ancient, face-cane plaques in polymer clay, *Ornament* published his article which resulted from his experimentation, "Millefiori Polyform Techniques," (summer 1989).

What surprised Jamey most about working with polymer clay was the extraordinary sense of creative accomplishment he felt after successfully reproducing the beads. He used careful and deliberate motions to gently coax everything into place. Until very recently, Jamey refused the use of any

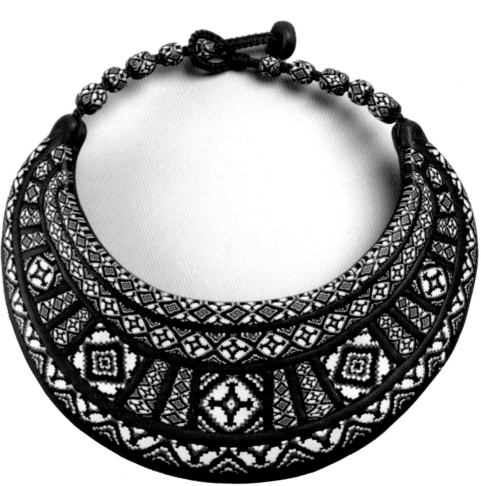

Lunate Collar. Jamey arranged a cane in different orientations to form the cross and diamond designs of this necklace. 9 in. diameter.

mechanical means to help him in his polymer-clay work. His intricately detailed face canes are even more impressive when one considers that he did all the conditioning and shaping of the polymer clay— even the flat slabs, by hand.

Jamey has taught polymer-clay workshops since 1988 and has

made presentations to several bead societies nationwide. These accomplishments helped establish his position as an early pioneer of the medium in bead design. In the future, Jamey plans to become more innovative and less grounded in glass technology.

Kathleen Amt
Mount Rainier, Maryland

"It is easy to become an artisan and polymer clay is only one means of expression. The harder part is having something to say and being able to express it."

ASTROLOGICAL IMAGES frequently appear in Kathleen's work. As a child growing up in the Black Hills of South Dakota, views of the constellations in the night sky, and conversations with her grandmother, sparked a lifelong interest in astronomy. She once asked her grandmother what the word "imagine" meant. Part of her response to Kathleen was that when you look at the stars and identify the constellations, that is imagining. In Kathleen's mind, she made the connection that "to imagine" was "to think." The correlation continues to be influential in her creative approach.

A love of creating objects led Kathleen to pursue a career as an artist and teacher in metals, ceramic, and fiber. She built and operated a ceramic studio in Woodville, Virginia, from 1975 until 1980 when a neck injury caused her to seek less arduous crafts. During her ceramic period, she worked with colored porcelains and became familiar with the neriage and millefiori work of Jane Pieser.

In 1986, Kathleen studied and taught at Pyramid Atlantic, a center for books, prints, and paper, in Washington, D.C. At that time, Kathleen Dustin was using caning techniques with polymer clay

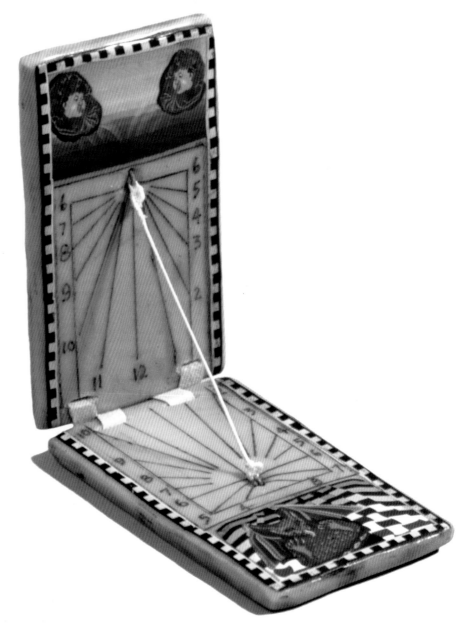

Sundial. The look of real ivory was achieved by sanding and buffing ivory-colored polymer clay to a high sheen. The markings on the dial were transferred from photocopies onto the polymer clay before firing, and the color images are cane slices. Kathleen incorporated the historically accurate, white linen thread in the design of this working, hand-held sundial. 3.25 in. x 1.75 in. x .5 in.

similar to those Kathleen Amt had used in porcelain. Inspired by Kathleen Dustin's work, Kathleen Amt began to incorporate polymer clay into her handmade books. One of her early books, Alice, was assembled from polymer-clay pages hinged together. The book's imagery was created by laminating slices from many different canes. A hot press was used to imprint the text onto the polymer-clay pages.

Now, as well as books, her detailed canework is used to create jewelry, games, toys, buttons, wall hangings, and masks.

Many of her cane series are designed to work together thematically. Each series uses the same background color so she can later combine them into one seamless collage. Two of her more recognized cane suites are The Zodiac, which includes intricate representations of the 12 astrological signs, and Alice in Wonderland, a series of 14 canes from Lewis Carroll's novel which include many characters such as Alice and the Cheshire Cat.

In 1990, knitwear designer Lee Anderson asked Kathleen to illustrate the page borders of her books. It took Kathleen several months to develop the color palette for the project and two more months to produce the 80 polymer-clay borders themselves. Each border echoed a design element or color note in the knitwear featured. This venture offered Kathleen invaluable experience in the design and execution of millefiori canes. The end papers of *The New Clay* feature canework from these borders.

Rather than reproducing the same designs, Kathleen prefers to create a series of between six and 12 pieces. She then moves to another narrative or takes a different approach and applies the same canes in different ways. Her ideas

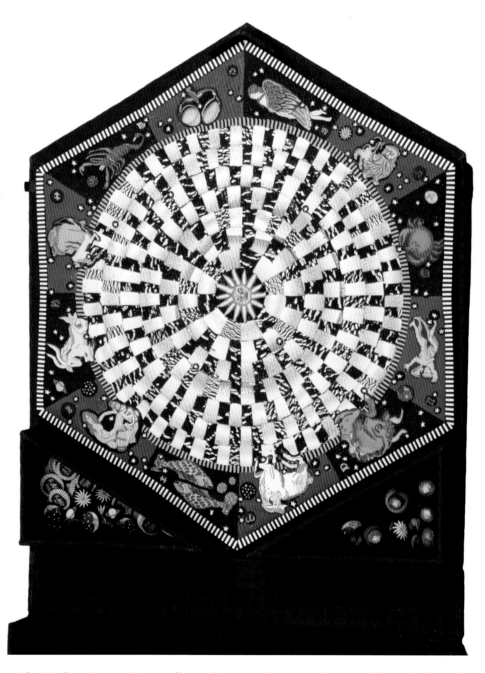

The Zodiac Game. Cane collages decorate the game pieces and board, all made entirely of polymer clay. Along with conceptualizing and designing this playable game, Kathleen made an elaborate, hand-printed instruction book and its fabric-covered box. 11.5 in. x 13 in. x 1.5 in., closed dimensions.

White Rabbit Pin. (left) This pin features a collage of eight different canes along with fractured metal leaf. 3.5 in. x 4 in.

are kept fresh and exciting by alternating between making jewelry and books.

Kathleen's work is produced in her studio which occupies three rooms in her home. One room houses two printing presses, an impressive collection of antique cold-type, a large inventory of handmade and machine-made papers, and numerous books in progress. She uses this room to print limited-edition cards, book covers, and the pages for some of her books. Wooden game boards decorate the walls of a second room which contains an antique desk and two photocopy machines.

The largest space, and the one with the best light, houses her massive collection of uncut millefiori canes. Large wooden office trays covered with plastic protect her canes from dust and allow Kathleen to see at a glance which canes are available. She arranges some canes thematically and others according to color. Two large tables serve as an assembly area for her handmade books and jewelry. A separate area is reserved for drilling and buffing. Several large bookcases are jam-packed with reference and inspirational books. Further inspiration is derived from several compartmented trays filled with polymer-clay beads, components, new beads, and antique beads from around the world, all loosely arranged by color in a dazzling array.

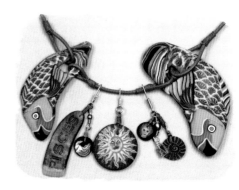

Pisces Necklace. (right) Kathleen made this necklace in preparation for a trip to Japan, where goldfish are considered good-luck talismans. Wire armatures reinforce the tails of the pendants. The small plaques and tags are removable from the leather cord. 28″ in. long.

Birthday Book. This date book features a polymer-clay cover made using the mokume technique and millefiori-cane embellishment. The internal pages are hand printed. The non-adhesive binding was chain stitched with waxed linen thread. 5.75 in. x 3.5 in.

PIERRETTE FIRST used polymer clay for model making and sculpting while studying industrial design at Pratt Institute in New York. It was not until 1987, when she moved to Washington, D.C. and discovered Kathleen Dustin's detailed canework, that she started using polymer clay in her jewelry designs. Kathleen's work inspired Pierrette to explore the millefiori technique with polymer clay. The bright, bold, and simple images of Pierrette's playful jewelry and sculpture are inspired, in part, by the mosaics of the ancients. From these beginnings grew Brown Dog Designs, her now successful full-time business.

Pierrette began designing and building her own mosaics of polymer clay. Her earliest attempts were flat plaques of geometric design and simple images. Familiarity with the techniques encouraged her to go back to three-dimensional work and to build small vessels and sculptures. After conceiving an idea and developing it on paper, she then makes her tiles. Hundreds, or even thousands of tiles, in different colors, sizes, and shapes, are required for each piece. She forms a base out of polymer clay to which each tile is painstakingly applied. When she is satisfied with the final composition the piece is fired, cooled and grouted (with soft polymer clay). A final firing is done before she buffs the surface.

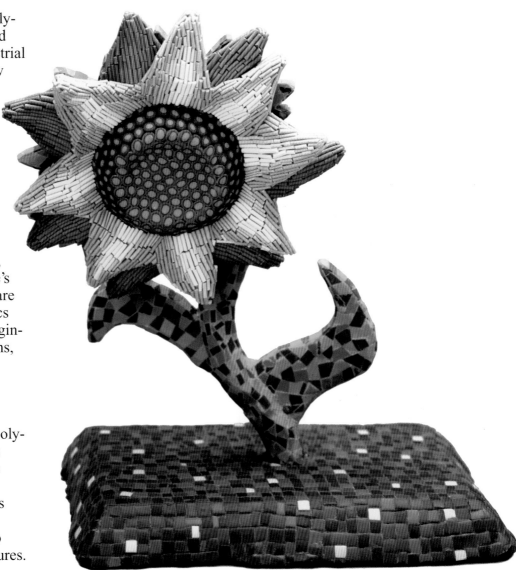

Sunflower. A polymer-clay base of the basic form was covered with thousands of prefired polymer-clay "tiles." 8 in. x 6.5 in. x 4.5 in. (Photograph by Glenwood Jackson.)

Pierrette has traveled to China and South America to study drawing and illustration with her art mentor, Barbara Carr. The colorful pictures Pierrette drew on those trips remain with her and continue to influence her work.

Laura Balombini
Blue Hill, Maine

"I hope these stepping stones in my artistic development, whether they are in clay, fiber, jewelry, or clocks (time has recently become a new element), are enjoyable entities unto themselves. After all, the road is difficult enough, and appears to have no end. I may as well enjoy the passing scenery."

LAURA STUDIED ceramic sculpture at Edinboro University (Pennsylvania), in the 1970s, with Steven Kemenyffy, who created richly inscribed raku platters in collaboration with his wife, Susan. Laura found it motivating to work under successful artisans such as the Kemenyffys and feels it helped her to achieve her place as an artist in the craft world.

Between 1987 and 1990, most of Laura's work focused on fibers, including woven and painted silks. Following a move to the Maine coast in 1989, she discovered polymer clay while looking for a way to make buttons for her clothing designs. Now, her repertoire has grown to include beads, brooches, earrings, wall hangings, boxes, clocks, and mirror frames—all made of polymer clay.

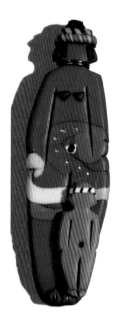

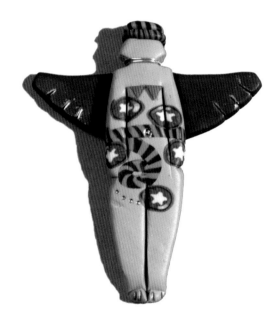

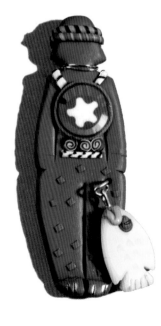

Mother and Child, Angel, and Fisherman's Friend Pins. Laura relies on simple techniques and symbolism to convey her ideas. These spirit brooches are meant to protect the wearer. She has combined polymer clay with silver wire, niobium wire, gold-filled wire, and metallic paint. Each 3 in. x 5 in.

Deborah Banyas and T.P. Speer
Oberlin, Ohio

"We absolutely love what we are doing. Everything is a collaboration. Even though the other may not work hands-on on a piece, we sit and talk about what works or not." -D.B.

DEBORAH STUDIED printmaking and photography while in art school, but she always felt most comfortable working with fabric. Her fondness for fabric led her to begin making painted-fabric dolls in 1981. T.P., a graphic artist specializing in original lithographs and etchings, was interested in trying something more sculptural. As a result, he and Deborah began "playing" with polymer clay. Collaborations between the two resulted in assemblages that incorporate Deborah's sewn figures and T.P.'s graphic images. Now, many years later, they use polymer clay to make beads, heads, hands, feet, and small ornaments for their sculptures. In the future, they would like to make a series of small shadowbox tableaux and utilize more polymer clay in their designs.

El Arco de Perro or *Arch of the Dog* is one in a series of four niche pieces. Each niche starts as idea they develop through a series of rough thumbnail sketches. During the construction phase, they attach painted mat board to a wood frame and Deborah sews and stuffs the figure's body. Polymer clay forms small tiles, inlaid segments, bones, and the figure's extremities. As they progress, they make decisions about adding further embellishments. T.P. and Deborah like to consider the ebb and flow of a piece before they add anything. They believe their work remains spontaneous by not working from a definite blueprint.

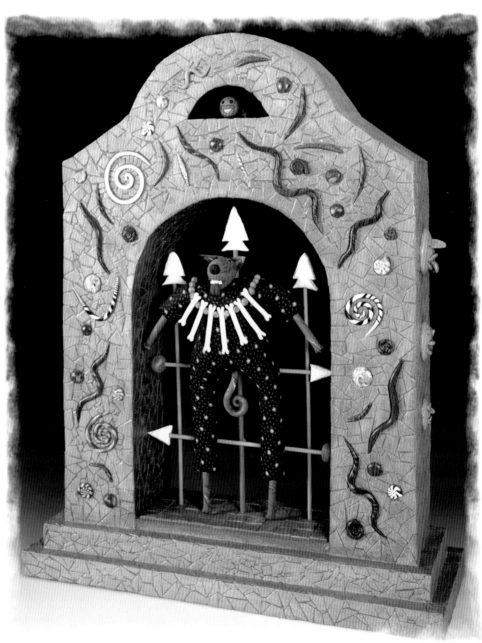

El Arco del Perro. This niche assemblage is made of polymer clay, wood, brass, stuffed cotton, rag board, acrylic paint, and wire. 36 in. x 26 in. (Photograph by John Seyfried.)

Pat Berlin
McLean, Virginia

"My idea and approach to jewelry is that the wearer should be adorned with a small, original work of art."

PAT, A LIFELONG ARTIST, is known for her willingness to experiment and try new things. Along with polymer clay, she has worked in painting, papermaking, printmaking, pottery, and fiber. Pat's multimedia background allows her to combine polymer clay with other media. Hard geometric shapes do not appeal to her, and she prefers to take a "painterly" approach with polymer clay. This has led to Pat's use of abstract millefiori canes and ambiguous imagery in her work.

Pat finds the work of several contemporary artists from New Mexico, such as Nieato and Scholder, particularly appealing because they push beyond the rules and paint for themselves instead of for public acceptance. She feels that their work is not "safely decorative," and Pat tries to assimilate their philosophy into her work.

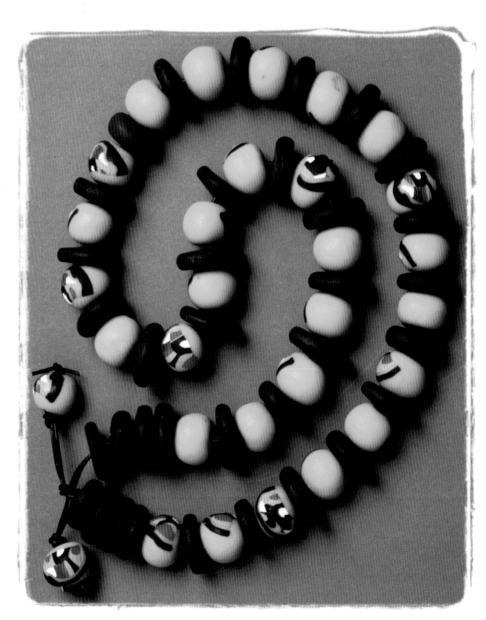

Black and Lime Necklace. Some beads in this necklace incorporate abstract millefiori canes in a neon-bright color scheme. Along with the strident contrasts in color and value, the variance in bead shapes and their stringing order results in a visually interesting rhythm. The polymer-clay beads are strung on leather cord. 26 in. long.

Melissa Brown Bidermann

Granada Hills, California

"Something about a gourd's light weight and smooth texture makes it irresistible to most people. Transforming gourds into rattles gives a person a logical excuse to hold them. The centering effect that they have upon you is an added bonus."

MELISSA WORKED with baskets and gourds for several years before taking her first polymer-clay workshop. The combination of polymer clay with other materials seemed natural to Melissa when she learned that it fires at low temperatures (around 250°F). Antique trade beads had been used to embellish her vessels for a long time, so decorating the gourds with millefiori canes seemed like a logical extension. The combination of the gourds' organic shapes, the vibrant colors of polymer clay, and the intertwined history of trade beads, basketry, and gourds, immediately excited her. In 1989, Melissa went one step further and transformed the polymer-clay-covered gourds into rattles.

Trade Rattle. (right) This rattle was created from a polymer-clay-covered gourd adorned with leather, brass, glass beads, and wood.
15 in. x 3 in.

Copper Quilt. (below left) Melissa applied polymer clay to the surface of a gourd from her garden and further embellished this vessel with copper and brass.
5 in. x 4 in.

Martha Breen
Berkeley, California

"I'd close my eyes, see patterns and play with them, and change and rearrange them in my mind, but it never occurred to me that I could do that for a living."

WHILE LIVING IN India as a child, Martha became fascinated with patterns and colors. After receiving a Bachelor of Fine Arts from Indiana University, where she specialized in printmaking, Martha spent most of the next ten years working as an illustrator and designer. During that time, she also served as an archaeological draftsperson on several digs in Greece, where she discovered a glass-mosaic wall near Corinth. That mosaic, created about 400 A.D. for a temple built as a tribute to the Egyptian goddess, Isis, was of particular interest to her because of its rich patterning.

Martha was first inspired to try polymer clay by the patterns she found in Pier Voulkos' work. "It occurred to me that you could do stuff in patterns that hadn't been thought of—that you could push millefiori as far as your imagination would take you."

Drawing on her knowledge of the millefiori technique used by glass artists, Martha began to make simple, bold canes in primary colors. She now works full time in her studio, affectionately called "Chez Beadlam," producing polymer-clay jewelry, boxes, and picture frames. Ethnic fabrics, quilts, and traditional American Indian beadwork provide inspiration for many of her cane designs.

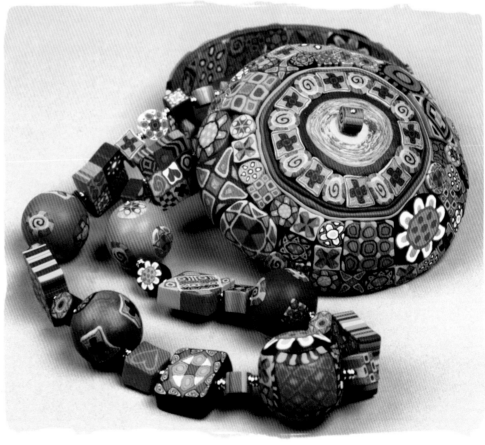

Necklace and Box. Martha used many of the same millefiori canes to create her beads and to cover the box's Plexiglas form. Necklace: 24 in. long, box: 4 in. diameter.

12

Shellie Brooks and Doug Quade
Cambridge, Massachusetts

"My 12-year experience as a professional ceramic artist is influential in my jewelry designs. In addition to comfort and wearability, the shape and volume of the pieces are important factors." -S.B.

THESE PIECES are collaborations between Shellie Brooks and her husband, Doug Quade, who designs and constructs most of the millefiori canes. Patterns and colors in nature often provide departure points for his cane designs. The movement and color play of a Hawaiian volcano inspired the *Haleakala II* series while the *Feline* cane series takes its inspiration from the markings on tigers and jaguars. The lushly tropical *Ruby Fruit Jungle* series, named for a book by Rita Mae Brown, is an adaptation of a colorful coleus stand in their garden. For each color story, Doug makes as many as twenty-five different canes.

The canes become the library from which Shellie works. By incorporating several slices from many different canes, she achieves the illusion of depth. Shellie particularly enjoys the challenge of designing something new and strives to make her jewelry both wearable and aesthetically pleasing. Her repertoire of 12 to 15 different styles is constantly evolving to achieve these goals.

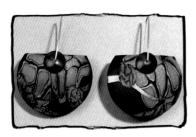

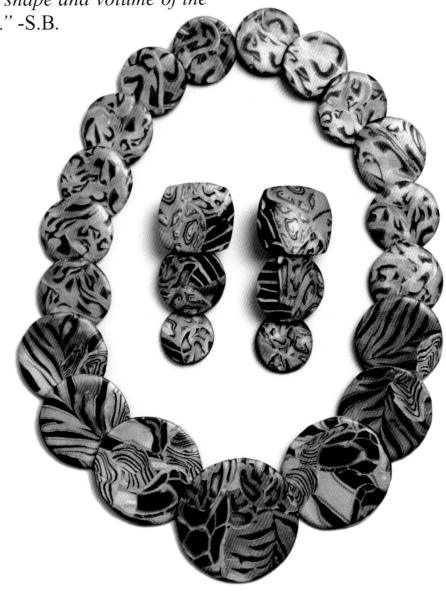

Feline Necklace and Earrings. This necklace is fashioned from a graduated series of thin discs laminated with millefiori cane slices. Interlocking loops of wire on the back of each disc link them together, allowing the necklace to conform to the wearer's neckline. A variation of this linking system was used to construct the earrings. Necklace: 20 in. long, earrings: 2.5 in. long.

Haleakala II Earrings. (left) A Hawaiian volcano inspired the canes that Doug made for these earrings. 2.5 in. x 1.75 in.

13

Maureen Carlson
Prior Lake, Minnesota

"I love the ease of working with polymer clay. It draws the creativity out of people, including those who were discouraged about art when they were children. It is versatile enough that it can keep one fascinated and experimenting for years."

MAUREEN USED TO make folk-art forest people out of bread dough, but was not satisfied with its durability. A fellow artist encouraged her to try polymer clay in 1979. Since then, she has made hundreds of dolls and has taught polymer-clay workshops on doll sculpture and jewelry making. In addition to making four polymer-clay videos, Maureen has written a project book and numerous magazine articles. She loves teaching and possesses a unique ability to establish the atmosphere and techniques that encourage and allow others to reach inside and find their own creative selves.

Maureen's innate creativity has allowed her to discover, express, and experiment in ways which surprise and enrich. "There is much creativity out there that is not touched by the traditional arts community. I do both whimsical and serious figures, which, when I am successful, draw the viewer into self-discovery."

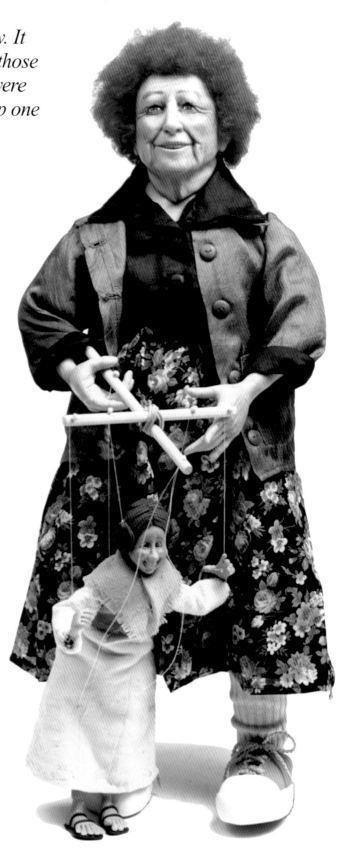

Never Too Old to Play. Maureen enjoys making female dolls with their own identity and personality. 20 in. tall.

Pat Corrigan
Pawling, New York

As AN ARTIST, Pat finds inspiration by trying new techniques and using different materials. Besides being an art teacher, she is a self-taught weaver and an accomplished watercolorist. She discovered polymer clay at a local craft fair and became intrigued by its potential. A week-long, intensive workshop led by Tory Hughes at Bennington College in Vermont was a great influence on Pat's work.

At that workshop, Pat learned to use polymer clay to mimic other materials and this provided the impetus for her *Wild Woman* necklace.

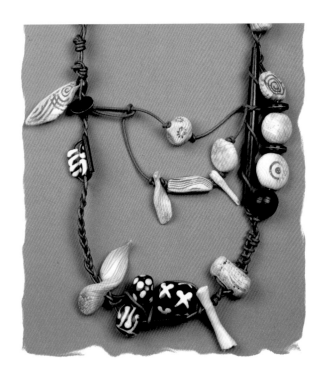

Wild Woman Necklace. This necklace combines polymer-clay beads with bone, glass, horn, and wood beads on leather cord. 36 in. long.

Ann Curtis
Alexandria, Virginia

"My dolls speak in ways I find enriching, contemplative, and spirit filled. Many of them impart poetry, dream fragments, and positive energy that facilitates healing in myself and others."

UNTIL RECENTLY, Ann's artistic focus was one-of-a-kind art wearables and the occasional art quilt. She now gives her full attention to doll making. By combining fibers and polymer clay she has tapped a mode of self expression she hopes to explore further.

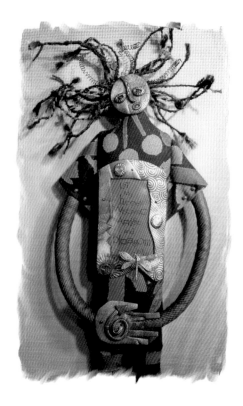

Doll. The quote on the doll is from German poet, Rainer Maria Rilke. 34 in. long. (Photograph by Ann Curtis.)

What is your favorite tool?

My main tools are: a tissue blade, a Kemper needle tool; a pasta machine, a toaster oven, a flexible shaft drill, a drill press, and a "carrot" tool inspired by Maureen Carlson. I appropriate and experiment constantly with other tools. My pasta machine was originally purchased for making "neat" geometric shapes. It soon became my mixer, and my tool for decorative sheets. It also serves for translucent layering, mokume gane, and cuts of thin sheets which become my "pencil lines" in complex canes. Each tool becomes a favorite as it builds its repertoire.
- Kathleen Amt

My favorite tools are my hands! They will do almost anything I need to do.
- Jamey Allen

A pasta machine for rolling sheets and marbleizing color.
- Laura Balombini

I couldn't do it without my food processor. For the first ten years that I used the polymer clay I did not have one, and I don't know how I did it! I must have really wanted to make those little people. A close second would be my pasta machine. It doesn't take up much counter space and it quickly rolls even sheets for either people dressing or millefiori building.
- Maureen Carlson

A small metal tool with a bowl on one end used with clay.
- Claire Laties Davis

My hands—they are always there and have sensory feedback.
- David Edwards

Claire Laties Davis
Edgewood, Rhode Island

Oranges Grow High on a Tree. This is one of Claire's large polymer-clay wall pieces. She plans the composition of a wall piece while sketching, and then makes paper stencils of the major shapes to aid in their cutting. A bowl-shaped ceramist's tool adds interesting surface texture to the large polymer-clay areas. Note the small figure hidden in the leaves. 8 in. x 12.75 in.

My hands and my imagination. They never let me down.
- Melissa Brown Bidermann

My hands are my favorite tools. I trust them to do everything I want and to create more than I was expecting. After that, well, I'd say the old dinner knife that my father filed smooth, so I can cut, lift, tap things together, make clean curving edges, and shape hard polymer clay. Its weight fits my hand, and since he died recently, I like the continuity of him making me a tool that works so well. I'm still here making things as he would have wanted to be doing. This knife links us.
- Tory Hughes

Two pieces of plate glass with rounded edges. I use these pieces of glass to reduce round canes, to bevel the edges of flat pieces, and to squash balls of polymer clay into round discs to be used as earrings or buttons.
- Carol Shelton

16

Andrew Denman
Orinda, California

"Sometimes I will envision something in my head, try to get it out, and it is very difficult."

ANDREW HAS WON many awards for his stylistically diverse drawings and paintings. His works range from realistic renderings of wildlife, to pieces that incorporate colorful fantasy images, to those containing images of dark and mysterious monsters. To combine his interest in wildlife and his three-dimensional artwork, Andrew started sculpting with polymer clay.

At the age of eight, Andrew began using polymer clay to make birds, lizards, and snakes for his mother's doll houses. As his work evolved, he sculpted life-sized South American frogs and lizards. Wire frames aid the sculpting process and give strength to his frogs' delicate appendages. After firing the frogs, he paints them with acrylic paint, striving to make his sculptures appear as lifelike as possible.

"I like to make my sculptures as realistic and true to nature as I can, to show people that nature produces colors in far more brilliant and dazzling patterns than man can ever imagine."

Ornate Horned Frog. Andrew sculpted polymer clay onto a plastic egg to achieve the bulbous frog body that he painted with acrylic paint. 2.5 in. x 3.25 in. x 2 in.

Poison Arrow Frogs and Limestone Salamander. (right) These polymer-clay frogs and salamander are sculpted on wire frames and painted with acrylic paint. Between 1.5 in. and 5 in. long.

Françoise Durham-Moulin
Prince George, British Columbia, Canada

FRANÇOISE STUDIED fine arts and ceramics in Belgium before moving to Canada. In 1985, she began using polymer clay to make jewelry and postcard illustrations. She loved to meet the people at the shows where she sold her jewelry and hear their comments on her work.

In 1987, Françoise won a competition for a mural installation in Vancouver and chose to use polymer clay. The 12-foot-by-8-foot mural posed a challenge to her. She needed to be able to make manageable pieces of a size that she could fire in her oven. The solution was a puzzle-like construction which gave Françoise the added benefit of being able to skillfully hide seams between each "puzzle piece" behind objects in the mural. With occasional help from her husband, she mixed the colors and conditioned by hand the 450 pounds of polymer clay used in the mural. The ambitious project was completed in just three months.

Aquarium in the Sea seems like a small undertaking in comparison. A collector who saw her larger mural, commissioned Françoise to

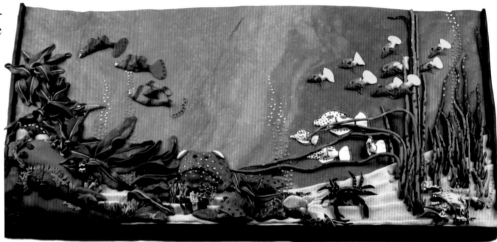

Aquarium in the Sea. 36 in. x 13 in.

do this wall piece. Except for the aquatic theme, he gave her total flexibility on the project. She used a lot of white and transparent polymer clays when mixing her colors to foster the illusion of water.

More recently, along with making humorous sculptural jewelry, Françoise has used polymer clay to illustrate a children's book. The author, Richard Thompson, saw her jewelry and thought that her whimsy and the bright colors of the polymer clay would be the perfect combination with which to illustrate his book. Each of the 11 intricately-detailed illustrations uniquely captures the childlike playfulness of the story.

Fish Pin. 5 in. x 5 in.

Fish Earrings. 1 in. x 1 in.

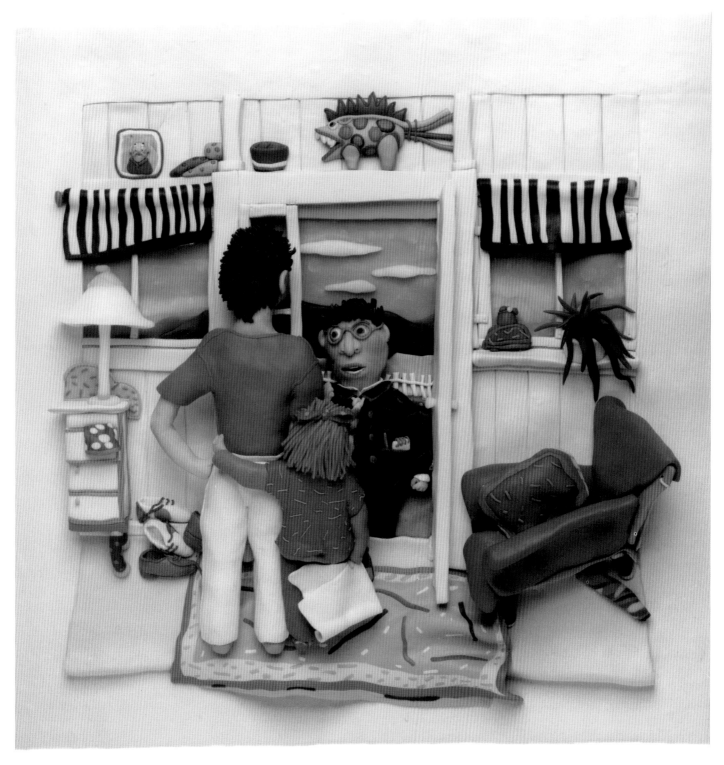

Fransçoise's illustration from *Jill and the Jogero* by Richard Thompson. 12 in. x 12 in. (Published in 1992 Annick Press, Ltd., Toronto. Photograph by Tim Swanky.)

Kathleen Dustin
Bellaire, Texas

"Technique takes a back seat to concept in my work. My techniques are pretty straight forward; primarily millefiori, sculpting, and press molding."

IN THE EARLY 1980s, while traveling in Austria, Kathleen bought some polymer clay. She then used it to form the faces, hands, and feet for a series of soft-sculpture female figures. After returning to the United States, Kathleen focused on ceramics and used polymer clay only occasionally. She was inspired to try millefiori canework when Helen Banes showed her a necklace made by Pier Voulkos.

Kathleen was an early pioneer in making complex millefiori canes out of polymer clay. She wrote articles for both *Ornament* and *Craft* magazines, conducted workshops, and inspired others with her polymer-clay work. Nan Roche, Kathleen Amt, and many others (including the authors of this book), were exposed to the possibilities of the millefiori technique with polymer clay through Kathleen's workshops. Just when interest in polymer clay as an artist's medium was gaining momentum, Kathleen moved to Ankara, Turkey, with her family. "Having had the chance to live in Turkey for three years afforded me many opportunities for artistic inspiration on a variety of levels."

A vast tradition of handmade textiles exists in Turkey, and the study of knitting, crochet, embroidery, carpet making, and kilim weaving has provided Kathleen a visual

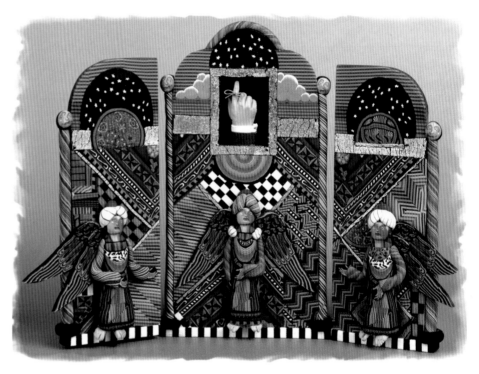

Byzantine Triptych Brooch Set. 5 in. x 7 in.

feast from which she draws inspiration. These influences are evident in the color combinations and the themes of her work.

The prehistoric, classical, Byzantine, and Islamic history of Asia Minor provided Kathleen many exciting, visual examples of times and ideas distant from her own tradition. With all these layers of history in her mind, Kathleen created the brooch, *Homage to Venus,* by combining renditions of a classical sculpture fragment, a Byzantine floor, and an Anatolian carpet. The three-piece brooch, *Byzantine Triptych,* features images from Byzantine and Ottoman traditions.

Homage to Venus Pin. 4 in. x 3.63 in.

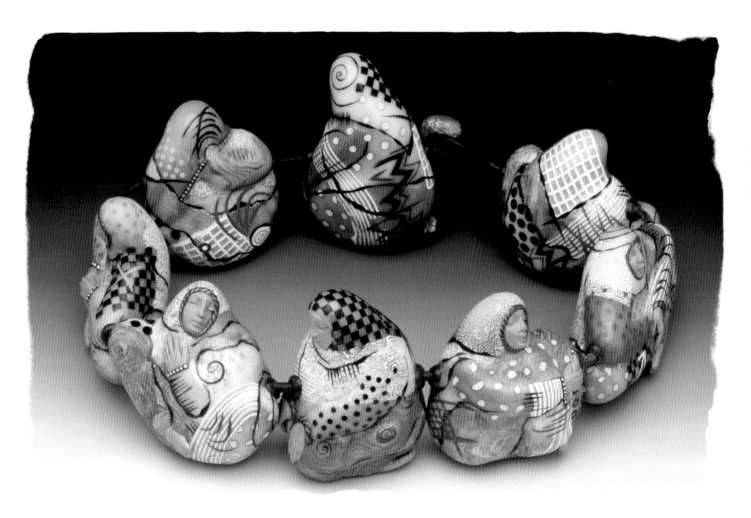

Village Women Necklace. The individual figures are modelled with translucent polymer clay. Then a combination of mille-fiori and mokume canes and colored pencils were added to the surface. The necklace is strung on rubber cord. 19 in. long. (Photograph by George Post.)

What is your studio like?

David Edwards
San Diego, California

Upstairs in my house there is one room and a bath. This is my studio. I am in my own world up there and can leave work in progress, close the door, and come back to it later. Since I have a refrigerator, a hot plate, a window, a telephone, and a stereo, my husband sometimes wonders if I will forget to come down. The polymer clay is stored in the refrigerator. This is not necessary, but I would hate to cure it partially if it got too hot.
- Jeanne Sturdevant

It seems, unfortunately, for consistent dedicated work, this medium needs its own space. I have a separate studio for polymer clay and other materials. Cleanliness is vital. The room must be free from dust and animal hair and have clean surfaces.
- Tory Hughes

I built myself a beautiful, spacious studio in my backyard with good light.
- Sarah Nelson Shriver

Generally, we confine most of our polymer-clay activity to a 20 foot by 15 foot area; however, several times a year we have trays, bars, findings, glue, caulk, weights, eggs, etc., covering every square inch of our loft.
- Steven Ford and David Forlano

Ruth Anne and I have a fairly large space devoted to our work. I think the thing that inspires both of us the most is having zillions of patterns around us to assemble, or use to inspire new patterns. We have 3 foot by 8 foot tables covered with patterned blocks leaving

Bird Shaman with Cat Pectoral. David incised this piece before he fired it, filled the impressions with acrylic paint afterwards, then sanded the surface. 2 in. x 1 in.

us an 8 inch square to work in. This is both frustrating and exciting to us.
- Michael Grove

I have a shared living and work space. My studio is a separate room with abundant natural light provided by a wall of windows. Daniel, my husband, built me an 8 foot by 4 foot work table with a Formica top. I use a convection oven because it is larger than a toaster oven and doesn't require the special wiring of a regular, full-size oven. Also, I use a Vent-A-Kiln, a hood that hangs over the oven on a pulley system, so I can raise and lower it to suck that "unpleasant" polymer-clay-baking aroma from the room.
- Pier Voulkos

El Viejo 2 Bolo. This bolo is one in a series of glow-in-the-dark, sculptural, bolo ties. The cord slides through two holes sculpted in the head instead of using a separate bolo finding. 2 in. x 1.5 in.

I have a whole bedroom for myself. No, the kids can't come home again. I use a six-foot cafeteria table covered with a large sheet of matboard which may be reversed when needed. I use tracing paper on top of this. The pasta machine is attached to the table, and I have plastic shoe boxes (for tools, cookie cutters, polymer clay, and a scrap box) all within reach.
- Pat Berlin

I have a room behind our garage with windows on three sides. From there I can see what the birds are doing in the woods beyond, and I can survey the majesty of the approaching thunderstorms. Since it is separate from the house, it is definitely workspace and I am distracted less by the other "parts" of my life. This privacy and control of my environment makes for an ideal work area.
- Maureen Carlson

Good lighting, a view of the Pacific, good music on the headset, and a clear view of the TV (to watch while conditioning.) It's a great spot, but visitors find it ugly. Lots of plastic bags and such.
- David Edwards

I work on a table with a laminated plastic top. I find a circular magnifying lamp indispensable because it provides excellent light and a close-up view when needed.
- E. Raye LeValley

My studio is an extremely messy room. I think the fact that it can stay messy helps me create. All my kids use it. They make things on the workbenches right on top of my work and play on the floor in piles of fabric.
- Barbara Morrison

I have a work table set up for polymer clay only. The only other art work I do is color-pencil draw-

Jacqui Ertischek
Anchorage, Alaska

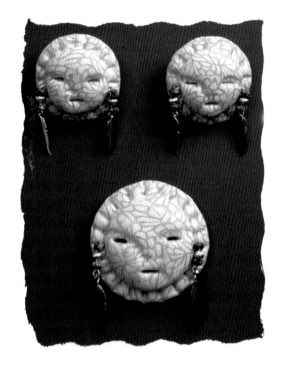

Spirit of the Sun Necklace and Earrings. The mask pendant and earrings, are constructed from canes of white and translucent polymer clays that mimic the subtle effect of eggshells. Jacqui gently modeled the features to add dimension. Metal feathers and turquoise beads hang from the masks. Pendant: 2.75 in. diameter, earrings: 1 in. diameter.

ing, which I can do pretty much anywhere as time permits. Everything is within easy reach which makes it most conducive to working. I have stacking drawers where I store slabs and rolls until I need them. The drawers keep them free of dust.
- Linda Pedersen

I have a 14.5 foot by 28' foot studio with 16 color-corrected, fluorescent tubes plus three big windows for light, lots of storage, worktables, lab sink, and counters.
- Wilcke Smith

I originally started the polymer-clay work in the kitchen. When I found two toaster ovens at tag sales, I moved the operation to my studio. A studio is essential for the artist who is into serious production. It's a place where kids, dogs, cats, husbands, etc., are not permitted to disrupt one's concentration. A working studio, aside from the many practical advantages,

also lends legitimacy to the creative process which often times can look like playtime. If the laundry is not right in front of you making you feel guilty, you're far more likely to be productive.
- Laura White

I am an incredible hoarder and have a workroom with shelves from floor to ceiling filled with boxes of everything imaginable. When I am on a project, I have everything I need on hand to complete it. This is my territory and I can get into an unholy mess without bothering anyone else in the house. I can leave things set up and come back and get straight back into it. I know where everything is.
- Jewel Lewis

I have a separate studio. The best part is never having to clean up or say I'm sorry.
- Martha Breen

Michele Fanner
Wanniassa, Australia

"Currently, I still am experimenting and enjoy making canes from graphs and drawings. I am constantly fascinated by the never-ending manipulation of these canes to form different patterns. It is like playing with my kaleidoscopes."

CREATIVITY IN SOME form has always filled Michele's life. She has been an avid handknitter for as long as she can remember and still enjoys designing knitwear for her family. In 1989, she began experimenting with polymer clay to produce buttons for her knitwear. Michele's teaching of folk-art painting and her study of pottery and ceramic painting have influenced her polymer-clay work.

Michele assumed everyone made canes the way she does and was surprised to discover her method is unique. She develops her cane designs using a puzzle-like construction. A new cane design starts with a line drawing and then a color drawing to check color relationships. These drawings become the patterns for cutting the cane pieces. Starting with one-inch-deep slabs of polymer clay, Michele uses a surgeon's scalpel, held vertically, to cut the cane segments. After she cuts the "jigsaw pieces" to fit together precisely, she consolidates and reduces the cane. This working method allows for asymmetry, color shading, and carefully controlled detail. She achieves many effects that are difficult to execute in the more traditional rod-and-slab approach to cane construction. Besides using this three-dimensional puzzle approach, Michele has made

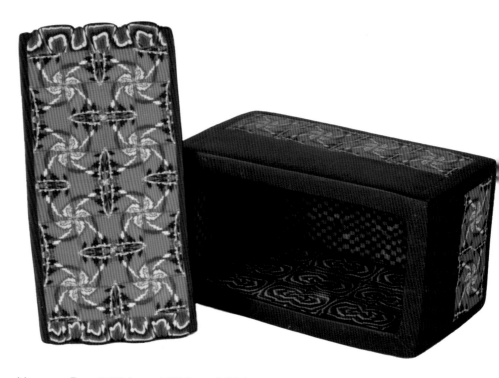

Morocco Box. 2.25 in. x 4.25 in. x 2.25 in.

numerous canes by charting them on graph paper and building the image in cross section using long square rods of polymer clay. Her initial patterns resemble needle-work charts.

After knitting a winter cardigan, using red, gold, purple and olive green yarns, Michele decided to make matching buttons. She constructed a millefiori cane resembling a section of the knit design, reduced it, and then joined four segments of the same cane to form

a pinwheel design. Michele used this new 'pinwheel' cane for buttons and in the construction of the *Morocco* box.

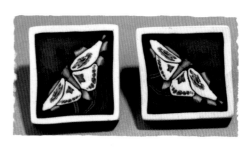

Butterfly Earrings. .75 in. x .75 in.

Do you experiment and play, or do you envision specific projects and follow them to completion?

I get to play and experiment when I am working intensely on a new idea. Usually I try to follow through on something I've been thinking about doing. While I am struggling, little things happen by accident that lead me off in other directions and are usually what I end up following. I was struggling with a flower design and it eventually turned into an orange.
- Linda Pedersen

I envision the work, make umpteen thumbnail sketches, scribble notes, re-work drawings, finally enlarge to full-scale, clean that up, revise, then go with it.
- Wilcke Smith

I seldom fully envision pieces before I begin. Instead, I start with a general direction that is subject to change as the piece evolves. Sometimes a pin will "tell" me what it wants to be. For example, a pin may become a more successful necklace. I like to experiment, improvise, and continually challenge myself. It is important for me to keep growing. Ideas beget ideas.
- Jeanne Sturdevant

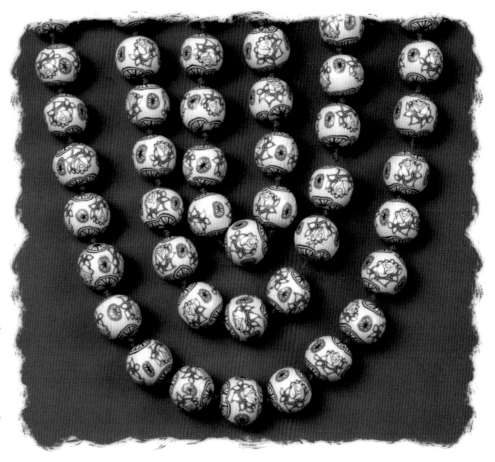

Bejing Necklace. *Michele Fanner.* 36 in. long.

Mead Cup. *Tory Hughes.*
4 in. x 2.25 in.

Steven Ford and David Forlano
Philadelphia, Pennsylvania

"Color, pattern, symbols, scale, and format all contribute to an artist's unique expression of oneself. This is a constantly evolving sense for us." -S.F.

STEVEN AND DAVID are a team of artists who may be better known as City Zen Cane. They both trained as painters and earned B.F.A. degrees from Tyler School of Art in Philadelphia. Steven also studied glass caning at Washington University in St. Louis.

In 1988, David and Steven tried polymer clay at the recommendation of Steven's childhood art mentor. After experimenting with the material for a few weeks, they realized they could not do everything by hand. Following the advice of a fellow artist, they purchased a pasta machine for rolling slabs and a food processor to assist in the conditioning process. They then embarked on a search for something that would make their work unique.

David attributes part of their success to their mindset. They were open to change, eager to make their jewelry business successful, and had a significant amount of time to devote to experimentation. Steven describes their early work as crude, primarily, basic spirals and stripes. A distinctive look to their work evolved as David and Steven became more comfortable working with patterns, mixing colors, and solving construction challenges.

For many years, Steven and David's signature style incorporat-

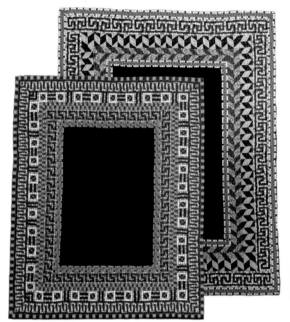

Mosaic Picture Frames. Between 6 in. x 8 in. and 8 in. x 10 in. outside dimensions.

ed bold, graphic designs featuring layered, color blends, in carefully graduated value steps. This work creates the optical illusion of three-dimensional space on a two-dimensional surface.

In 1991, Steven saw a beaded butterfly pin and realized that the butterfly's symmetrical patterning and natural beauty made it a good image for caning. A trip to Butterfly World in Florida, where butterflies live in recreated natural habitats, proved to be both educational and inspirational. Steven and David have since made ten

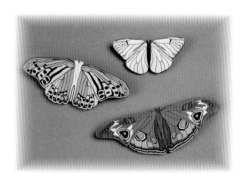

Butterfly Pins. Wingspan between 2.5 in. and 5 in.

26

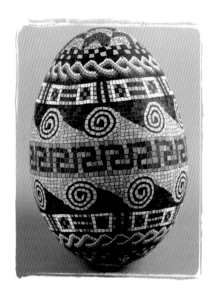

Mosaic Goose Egg. (left) An actual egg shell was covered with polymer-clay canes fired, sanded, and polished. It is not fragile once fired. 4.25 in. x 2.75 in.

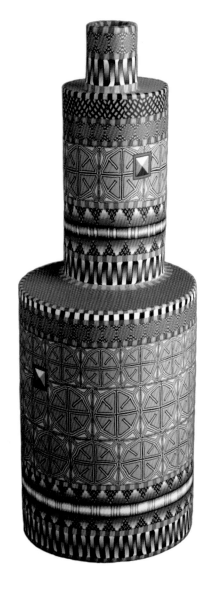

different butterfly and moth canes that they use to create pins and barrettes.

One question David and Steven are frequently asked about their work is: "How do you do it?" and they reply, "It is just like a mosaic." So in the fall of 1992, they decided to make some canes "just like mosaics." They use these "mosaic" canes to construct picture frames, vessels, and jewelry.

All of their designs are creative collaborations. David makes the large slabs of blended color gradations, and Steven assembles most of the canes. They find this division of labor creates the most consistent sense of scale and color saturation.

Its physical properties and the studio cost benefits are just a couple of reasons that they like working with polymer clay. They also find the caning qualities are remarkably close to glass, holding detail to an incredible level when reduced. The fact that some people believe that because polymer clay is plastic, it is only a material for "kitschy" things, does concern them. Over the past few years, both have witnessed changes in this attitude and have watched polymer clay become more accepted as an artist's medium.

Large Vessel. (right) This vessel was built on a piece of PVC pipe, covered with polymer-clay canes and then it was fired, sanded, and polished. 12 in. x 4.5 in.

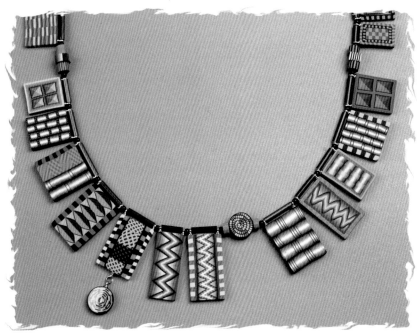

Flat Necklace. This reversible necklace is a combination of polymer-clay plaques, anodized aluminum tubing, and black onyx beads. The necklace is reversible. 23 in. long.

Michael and Ruth Anne Grove
Berkeley, California

"Our motivations for creating have changed. Currently, we are more interested in color and design than effects." -M.G.

RUTH ANNE AND MICHAEL are best known for their bold, graphic canework and their willingness to experiment. Currently they make boxes, beads, frames, jewelry, masks, sculpture, and vessels with polymer clay. Most of these consist of millefiori cane slices applied to the surface of the item being made.

In 1985, Martha Breen introduced Ruth Anne and Michael to polymer clay. At that time, they had fun just playing with it. Michael had abandoned his ceramics career to become a computer consultant and Ruth Anne was painting and drawing. As time went on, however, their playful use of polymer clay evolved into full-time careers for both of them.

They are lucky to have a large amount of space to devote to their work. Several long tables are so crowded with patterned loaves and canes, that they each end up working in an eight-inch-square area! It can be exciting and stimulating to be surrounding by so many canes, but the tight work space can be frustrating.

"The thing that motivates both of us most is having zillions of canes around to assemble and inspire new patterns."—M.G.

Their creative process is not dictated by a set routine. Sometimes one starts a piece only to have the other finish it. While both make millefiori

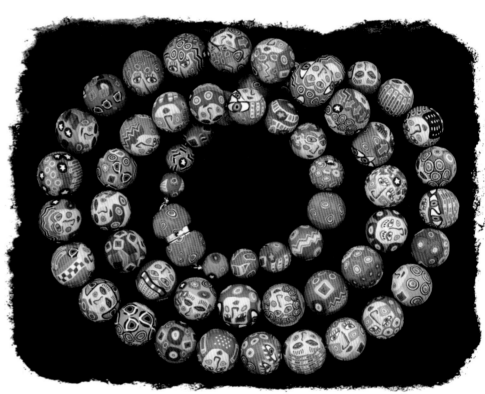

Face Necklace. 24 in. long. (Photograph by George Post.)

canes and often use each other's canes interchangeably, they do have a few "personal" canes that they use only for their individual pieces.

The first few years they worked with polymer clay, Ruth Anne and Michael focused exclusively on production work and Michael feels this helped them to develop discipline and hone their skills. Their interest in reproducing the same designs has since waned and now they create limited editions and one-of-a-kind pieces.

By organizing two group shows, Michael has challenged other artists to expand their perceived boundaries of the material. The first show he mounted in 1992, *Five Directions in Polymer,* included jewelry and other larger sculptural pieces. This show resulted in a book, *Five Artists - Five Directions in Polymer Clay* by Jamey Allen. The second show focused on masks, and included a large jewelry exhibit.

Box. 4.5 in. x 4.75 in. x 6 in.
(Photograph by George Post.)

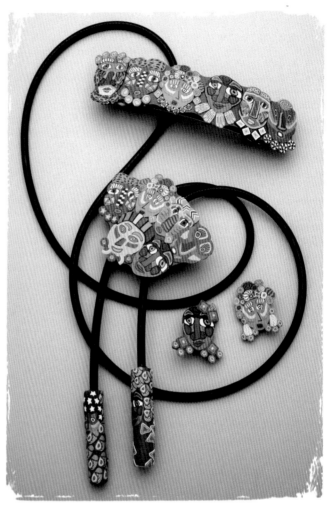

Crowd Scene. Bolo: 3.5 in., barrette: 5 in. x 2 in., pin: 3.5 in. x 2 in. (Photograph by George Post.)

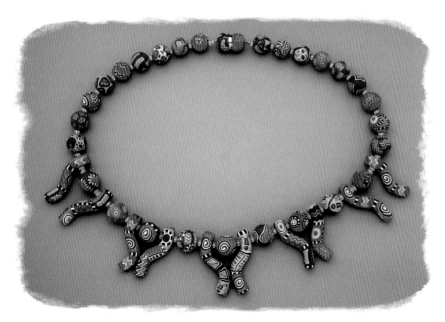

Apologies to Kandinsky. Kandinsky's geometric, squiggly shapes inspired this necklace. 23 in. long. (Photograph by George Post.)

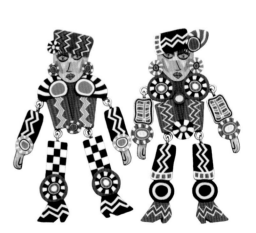

People Earrings. 4 in. long.
(Photograph by George Post.)

Lindly Haunani
Bethesda, Maryland

"The conceptual and experimental stages of putting together a piece are the most exciting for me. Working with polymer clay allows free reign of my imagination. I can indulge the fantasy of being an avant garde food stylist, for instance, or a fabric designer operating without color constraints."

DESPITE EARNING A B.F.A. in printmaking from Carnegie Mellon University in Pittsburgh, Pennsylvania, Lindly still considers herself a student. She continues to explore new materials with which she works. In 1989, a polymer-clay workshop led by Kathleen Dustin at the Torpedo Factory in Alexandria, Virginia, proved to be a pivotal experience. Polymer clay added a new dimension to Lindly's artistic explorations.

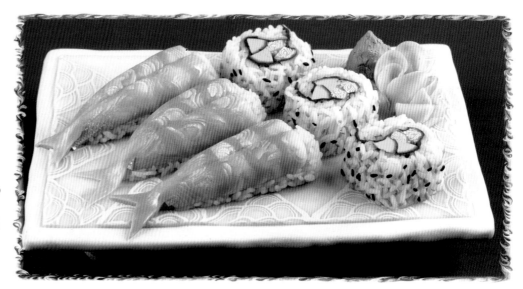

To maintain momentum in her work, Lindly likes to alternate among three different focuses: colored canework, translucent collage pieces, and experimentation. Her work featured here is part of an ongoing series of "sushi" pieces that employ translucent polymer clay.

The sushi platter is an attempt to portray the borderline between the real and the fantastic. To start, Lindly fashioned the body of the shrimp using slices from a mokume block made with silver leaf and transparent polymer clay. Then she made convincing reproductions of rice grains by hand-rolling pieces of translucent polymer clay. Each piece utilizes the techniques used to make sushi,

adding to the illusion. She applied touches of interference paint, highlighting the pickled ginger and wasabi. To complete the piece, Lindly decorated the polymer-clay platter with cane slices of a stylized Japanese wave pattern.

The collage pin incorporates slices of a "California Roll" cane, an avocado cane, "chameleon" canes, and an ink transfer from a photocopy of a sushi bar advertisement. Lindly added slices from a mokume block and texturing to form a collage on a translucent polymer-clay base. The chameleon canes are made with white and translucent polymer clays so that the thin slices take on the color underneath them.

Sushi Platter. This faux food platter incorporates polymer clay with silver leaf and interference paint. 8 in. x 5.5 in. x 2.5 in.

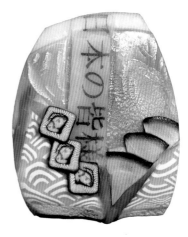

California Roll. Lindly used polymer clay, silver leaf, and a photocopy image transfer to create this pin. 2.13 in. x 1.75 in.

Tory Hughes
Trumbull, Connecticut

"I have an absolute belief in the creative ability of every human on the planet. The necessity is to recognize that ability and its positive, exciting implications for helping heal or join planetary beings. Creation is our birthright! Anywhere you begin to take your power as creator back, you begin to create a more responsible life."

POLYMER CLAY IS A recent discovery for many artists in this book. Tory, on the other hand, has worked intensely with the material for over 20 years. She began experimenting with it in the 1970s as a teenager in Germany. Since then she has developed a great understanding and feel for the possibilities and limitations of the medium.

For years, Tory was best known for her innovative stamp-collage pins. Those pins provided her with the opportunity to experiment and to perfect many techniques, including the use of transparent color blends, bronzing powders, stenciling, and texturing materials. By adding a variety of materials to the polymer-clay body itself, she could manipulate its texture and density. She also used a wide range of inlaid and overlaid materials, such as brick, gesso, glass, and mica.

In 1992, Tory made a conscious effort to pull back from the constant demands of her production work and devote more time to experimentation with imitative techniques and large pieces. Through trial and error, she was able to simulate ivory, jade, amber, turquoise, and coral with polymer clay. She combines her knowledge of color theory with the properties of translucent polymer clay to reproduce the color, texture, and opacity of these natural materials. Tory now spends most of her time pushing the perceived boundaries of polymer clay, and teaching her imitative techniques through workshops and a how-to video series.

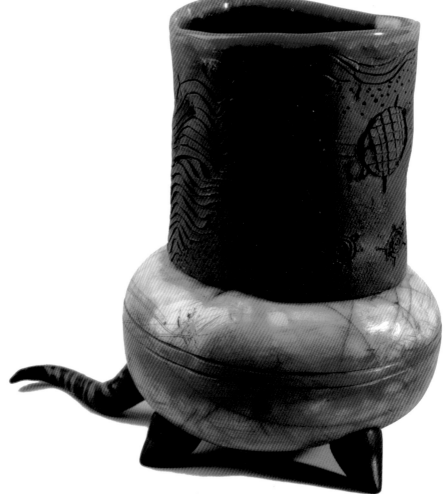

Walking Spot Pot. The contrasting surface finishes animate this vessel. Sgraffito, a method of incising the surface to reveal a different color underneath, was used to unify the highly polished areas which offset the flat matte areas. 7 in. tall.

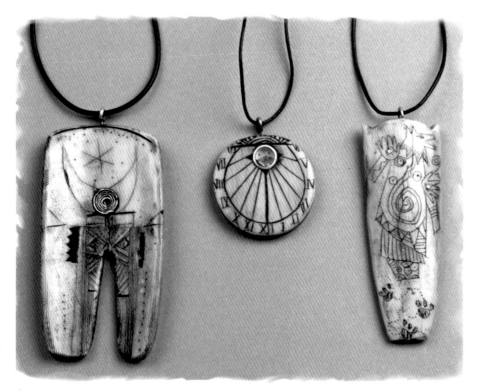

Scallop Shell, Trickster Coyote, and Priestess Pendants. 1.25 in. diameter, 3.25 in. diameter, 3.5 in. diameter.

Pin. This is one in a series of brooches Tory made in collaboration with Robert Dancik, a metalsmith. She encourages everyone to try collaborative projects. The pin is made of polymer clay and sterling silver. 2 in. x 2.5 in.

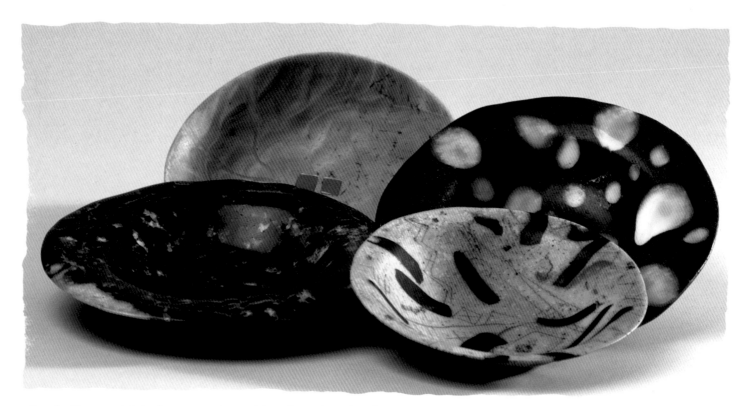

Bowls. Tory used light fixtures as the molds to form these bowls. Between 5 in. and 6 in. diameter.

Ramona Johnston
Santa Rosa, California

"I try to give the pieces a realistic flair. I imagine elves and fairies to have very human-like forms except for their ears and wings. I find sculpting the anatomical details challenging."

RAMONA HAS NO formal art training, but has always loved figure drawing. She began sculpting figures with polymer clay in 1990 as a way of combining her passion for figure drawing with her interest in costuming. Ironically, her first piece looked like a mythical creature who might not wear clothes, so she never added them. That piece inspired a series of imaginary creatures mounted within miniature glens.

Each figure is sculpted on a wire armature. A base layer of polymer clay is applied and fired before the actual figure is sculpted. Ramona likes to start the work with the head, because she feels it sets the personality and gender of a figure. After sculpting the head, the body and surrounding environment flow from within.

The Mushroom Fairie. 5 in. tall. (Photograph by Alan L. Bartl.)

If you had to limit yourself to three tools, what would they be?

A dental pick, razor blade and a potter's knife.
Deborah Banyas

A knife, needle tool, and a #1 round brush.
Maureen Carlson

A wooden pizza rolling pin, tissue blade and a small (half-dollar-size) biscuit cutter.
Pat Berlin

A blade, because it is the only tool that I cannot absolutely do without. I can hand mix colors and use my hands to press shapes, but my hands will not cut.
Michele Fanner

My three favorite tools for polymer clay are all cast-off dental tools given to me by my dentist. My favorite has a thick rounded-off point.
Jeanne Sturdevant

Realistically, if I could only have three tools, I would chuck it all. Tools are my joy!
Carol Shelton

Doris and James Keats
Los Altos, California

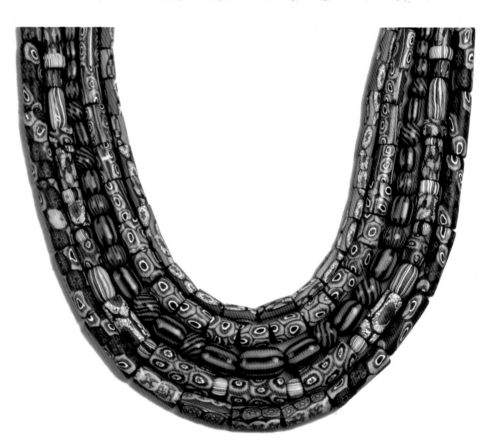

Trade Beads. Doris and James create these convincing reproductions of African trade beads, with the help of just two simple tools—a toothpick and a scalpel blade. They use complementary color combinations to excite the eye, and instead of using the traditional black color, they substitute deep purple. Each 1 in.

Diane Keeler
Luck, Wisconsin

"Whenever I start a doll, I go in with a plan, and try to make myself do something different."

DIANE HAS MADE hundreds of polymer-clay dolls over the past six years and still finds each new one an interesting challenge. When she began making the *Quilter*, Diane already had the rocking chair and knew she wanted to make a doll of an older woman quilting. She built a foil armature to conform to the shape of the chair and then added polymer clay in stages. "Older faces are easier to make and the exciting part is not knowing just where I am going to end up."

The *Quilter* is made entirely of polymer clay, except the hair and chair. The quilt is made of mille-fiori-cane slices, impressed with a tracing wheel to establish the illusion of quilting stitches. Diane imprinted both the collar and the hem of the apron with lace. She created the dress' matte finish by lightly pressing a piece of fabric on it.

Diane works on as many as nine dolls at once. She makes the dolls in stages, over a period of several days, and enjoys working long intense hours. Recently, Diane began making larger dolls with cloth bodies and polymer-clay heads, hands, and feet.

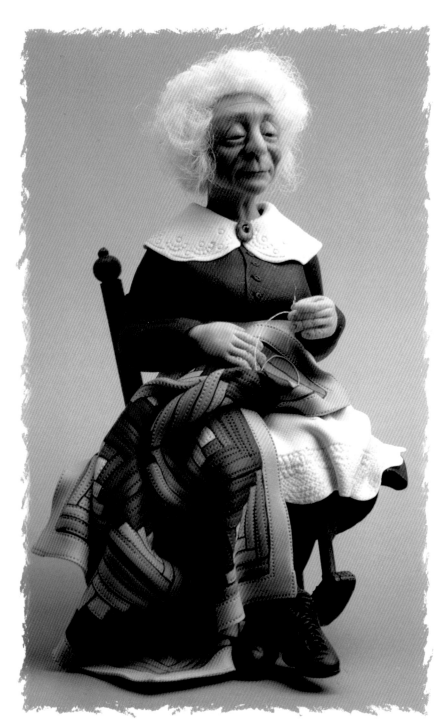

Quilter. 7.5 in. x 4 in.

Is there a "dream" tool that you would like to see?

How about an appliance to feed raw polymer clay in one slot, and have it come out conditioned from the other slot?
Jamey Allen

A mechanical kneader that keeps the polymer clay at 80°F.
Maureen Carlson

A punch that neatly and smoothly removes variable-size cores from a piece of polymer clay. Like a multi-sized leather punch, maybe.
David Edwards

Something that extrudes stripes in very small diameters to outline pieces.
Laura Balombini

A wife.
Martha Breen

A wider roller on a pasta machine.
Pat Berlin

We have a dream tool in mind, and I've heard it exists for $900; that is, an adjustable slicing machine. But for now we'll slice by hand.
Steven Ford

I would like to see a mini-extruder, with dies for positive and negative shapes.
Karen Kozak

The only other tool I would need (besides a pasta machine, tissue blade and long-handled needle-nose pliers) would be a 36-hour day or a pill which would eliminate my need to sleep.
Christie Leu

Doug Kennedy
San Francisco, California

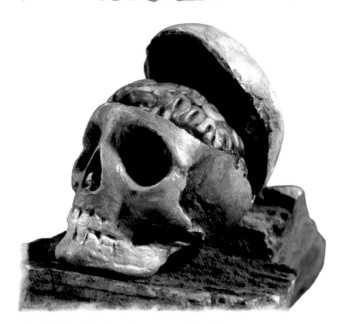

Skull. The illusion of porous, brittle bone was, in part, created by Doug's working method. He formed the general shape, fired it, and then refined the details of the piece by sanding and carving. The process revealed minute air pockets which he used to his advantage by applying acrylic-paint washes to highlight the surface texture and add color. Unlike most of his small sculptures, this polymer-clay skull has yet to be included in an assemblage. 2 in. x 2.25 in.

A dream tool for me would be a portable oven that is very large and light, with perhaps enough interior space for my larger pieces, and for future eventualities. Most tools you can make yourself.
Tory Hughes

My "dream tool" would have a smooth triangular face with slightly rounded edges. The face would be perpendicular to the handle. It would be made of polished steel, and I would use it to smooth areas that are difficult to smooth with
the tools that I have.
Jeanne Sturdevant

I don't have a dream tool. Mostly I use what I find laying around. I use a coffee stirrer to make bumpy surfaces. Another tool I have come to use came with an inexpensive nutcracker set. It has a curved little scoop-shape at one end and is round and tapered on the other end. I also use an old toothbrush for texture.
Linda Pedersen

Robin Kimball
Longmeadow, Massachusetts

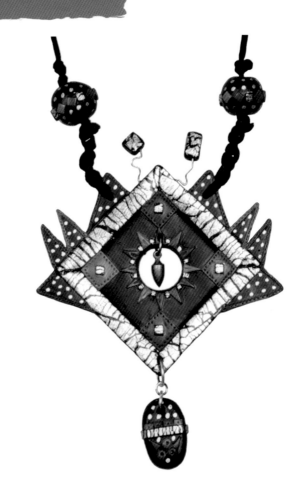

"I know what I want to do before I begin a piece. After laying out the colors, I add things until the piece is finished."

ROBIN HAS BEEN involved in art professionally since college. She started as a graphic designer and moved into printmaking, working with etchings and monoprints. Now she works exclusively in polymer clay. The challenge of incorporating different polymer-clay techniques with metallic elements such as wire, gold leaf, or cast charms is the aspect of the design process that she enjoys most.

Inflight Necklace. This necklace combines polymer clay, gold leaf, brass wire, and brass beads. It is strung on satin cord. Centerpiece: 3 in. x 4 in.

Mike Kury
Westminster, California

MIKE WAS A JEWELER for over 15 years before he decided to incorporate polymer-clay reproductions of Kiffa beads into his work. Original Kiffa beads are made of ground inlay glass, so Mike had to experiment with polymer clay a great deal to make satisfying reproductions. It was important to him to keep within their tradition, so he used a similar color palette and simple cane designs to create these convincing reproductions.

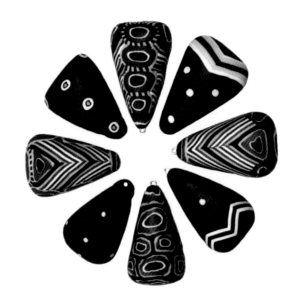

Kiffa beads. Each 1 in.

Karyn Kozak
Chicago, Illinois

"A good designer always watches for nuances and differences in what was intended and what actually occurs."

ONE OF KARYN'S earliest memories of art was watching her mother make traditional Polish Easter eggs, using a wax-resist method that required great attention to detail and patterning. This experience created a fascination with pattern and color that has stayed with Karyn and still influences her as she works in graphic design, with glass, or with polymer clay. The rich colors of polymer clay first drew her to the material. Karyn is always vividly aware of the colors around her. She constantly looks for subtle color changes or new risky combinations to use on her bottles.

The base of each bottle is a slip-cast porcelain form. Karyn covers them with slices of polymer-clay canes, then fires, sands, and polishes the surface. She accompanies each bottle with this poem she wrote.

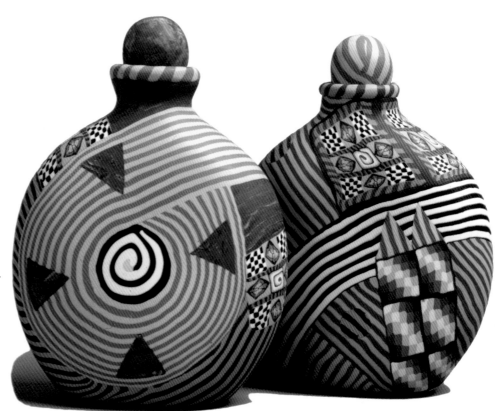

Bottles. Each 4.5 in. x 3.75 in. x 1.5 in.

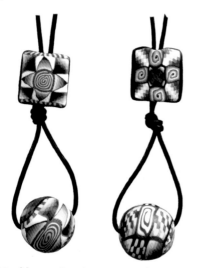

Necklaces. Beads: 1.13 in. diameter.

The Vessel

We grow up with,
and through a series of patterns.
Patterns of behavior, of attitude,
of dealing with crisis.
The patterns serve us well,
until they don't "work" anymore.
Then old patterns, old thoughts
must be let go
so we can cultivate new ones.
When something bad
seems to be holding you, write it out.
That is what you must let go.

Burn the words,
put the ashes into this bottle.
Letting go is scary, elusive, not easy.
It helps to have reminders
that we can do it.
Be grateful for your ability
to create new patterns.
To rise like the Phoenix
from the ashes of your own past.

38

Christie Leu
Shaker Heights, Ohio

"I spend a lot of time creating many patterns. I am drawn to bright colors and the juxtaposition of complementary colors. At any one time I usually have an array of 40-50 design loaves on my worktable, and pick and choose among them to create my designs."

CHRISTIE DESCRIBES herself as having a minor in art and a lifetime of making things. In 1979, when she began working with polymer clay, she made modeled jewelry and sculptures of her cartoon characters. Vibrant, colorful patterns began appearing in her work in the late 1980s, after she saw the works of several polymer-clay artists using the millefiori technique.

Christie enjoys the challenge of solving technical problems, such as assembling a necklace or suspending bubbles above her fish clocks. Each new construction teaches her something she can use in a future project. Her work often includes many small pieces wired together to achieve a desired effect. An example is the necklace, *Tumbling House of Cards*. The wire holding together the cane plaques is both functional and decorative.

Fish Clock. 11 in. x 6.5 in.

Tumbling House of Cards Necklace. (right) 8 in. diameter.

Sign of the Times. (left) This clock features sign language numbers cut from patterned canes mounted on a Plexiglas base. 9 in. diameter.

The Queen Within Wearing Heart on Sleeve Pin and **The Quizzical Queen Within Pin.** These miniature garment brooches combine polymer clay with beads, wire, natural fibers, and metallic threads. E. Raye LeValley molds the faces in porcelain presses and then alters them individually. Each 3 in. x 2.5 in.

Jewel Lewis
Christchurch, New Zealand

THESE *LADYBIRD* buttons are the result of Jewel's experimentation with very detailed and realistic millefiori canework. The value contrasts and highlights add to the readability of this cane. Cutting uniform, clean cane slices can be a challenge for many artists. Jewel developed a system to reduce distortion when slicing a cane. Here, timing is crucial, but the method produces good results. She places two-inch lengths of cane in the oven and fires them for seven minutes. While they are still hot, the canes are sliced and then returned to the oven to finish firing.

Ladybird Buttons. The button holes are cleverly incorporated into the spots on the ladybug's back. Each 1 in. diameter.

Liz Mitchell
Pittstown, New Jersey

In 1989, THE IMMEDIACY and stable nature of polymer clay lured Liz away from ceramic clay. Unlike many people, she enjoys working on several different pieces at the same time. Polymer clay allows her to set a project aside while she works out a problem. The problem solved, she can then go back to rework her piece, without worrying that it had dried out. Occasionally she will "take a piece too far," but feels it enriches the learning process.

Liz's color palette is constantly evolving. She departed from her conventional color choices and started using the muted tones she derived from mixing her scrap material with undiluted polymer clay. Some of these subdued hues are found in her *Scallion* and *Asparagus* mirrors which were inspired by antique vegetable prints. Experimentation with polymer clay has allowed Liz to expand her jewelry business to include home accessories.

Frog Switch Plate. 7.5 in. x 5 in.

Scallion and Asparagus Mirrors. Each 3.5 in. x 9 in.

Barbara Morrison
Missoula, Montana

"I am a strong believer in serendipity. I like to recycle cast-off finds - beads, wire, curler pins, transitors - whatever provides the right color and texture."

BARBARA HAS worked with polymer clay for over 15 years. Originally she used it to make life-like children and historic-costume dolls, but recently she has been making more elaborate fetish dolls. The image of her first fetish figure appeared to her in a dream. The picture in her mind was still so vivid upon awakening that she immediately made a two-inch fetish doll. Since then she has made many more "dream" dolls. Over time, the dolls have become larger and more elaborate. The inspiration for each doll is different: a small piece of beadwork, embroidery, or simply a color combination may spark a project. She adds bits and pieces until "it is overloaded enough." A believer in serendipity, Barbara enjoys using found objects, including wood, leather, beads, wire, curler pins, worry dolls, and transistors—anything that provides the right colors and texture for the piece.

Ceremonial Dish. Barbara used polymer clay to make the figure's hands and head. The dish held by the figures, made of polymer clay was covered with leather on one side, seed beads adorn the inside, and fibers and beads trim the edge. 10 in. x 10 in.

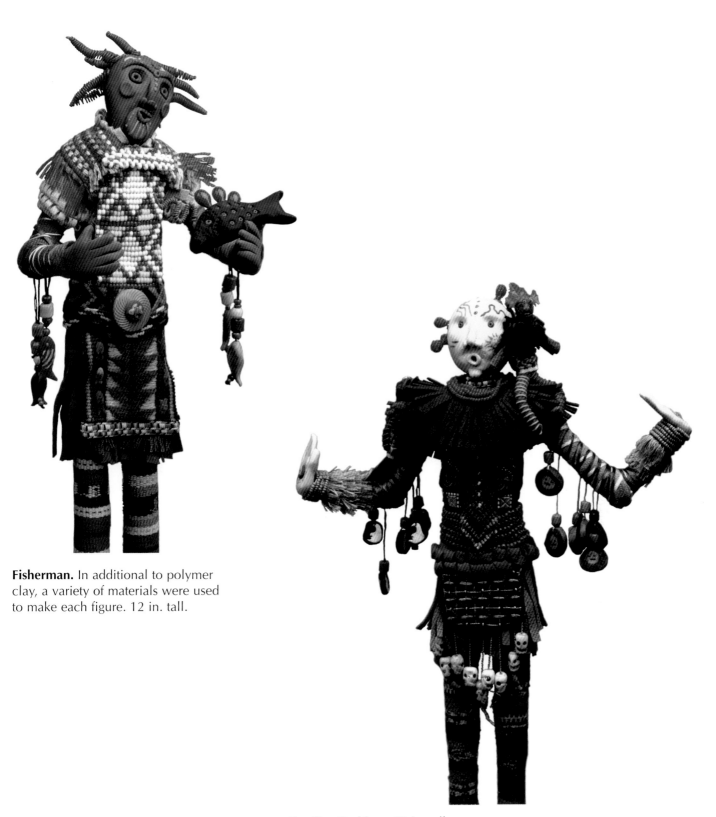

Fisherman. In additional to polymer clay, a variety of materials were used to make each figure. 12 in. tall.

Fertility Goddess. 12 in. tall.

Laura Liska Oakes
Sonoma, California

"In analyzing what I most enjoy doing and my best working habits, I've decided to pursue beadmaking. I like coming up with new designs, then spending time producing loose beads rather than pieces of jewelry."

LAURA IS A SELF-TAUGHT graphic designer who transformed her computer-programming business into a desk-top service. After a decade in that field, she made the decision to pursue something that allowed her more creativity and artistic expression. When she and a friend were looking for an alternative to store-bought beads to make Christmas gifts they discovered polymer clay. *The New Clay* revealed the process of making beads with polymer clay and opened a new world of creative possibilities to her. Laura was attracted by the potential for use of color, the tactile, hands-on aspects and the fact that it was a new medium, exciting, unexplored and challenging.

Early sales of her beads were encouraging, so she embarked on a period of intense study in color theory, design and jewelry making. After mixing hundreds of color tiles in value and saturation scales, she found new color confidence with a technique of her own invention. The Bargello beads are constructed in many sizes and shapes in carefully considered color combinations.

Flower and Leaf Beads Necklace. These beads made of polymer clay give the illusion of woven fibers. Beads between 1.25 in. diameter and .5 in. diameter. (Photograph by Laura Liska Oakes.)

Flower Beads. Laura combines her love of miniature artifacts with an exploration of color and visual texture as she constructs each bead. Each 1.5 in. diameter. (Photograph by Laura Liska Oakes.)

Square and Diamond Beads. (left)
With each bead, Laura's goal is to create something of visual interest and also something irresistible to touch. Each 1.19 in. x 1.19 in. (Photograph by Laura Liska Oakes.)

Bargello Bead Pendants. (below)
The beads were inspired by a very old form of needlepoint that uses thick yarn. Beads 2.38 in. x .75 in. (Photograph by Laura Liska Oakes.)

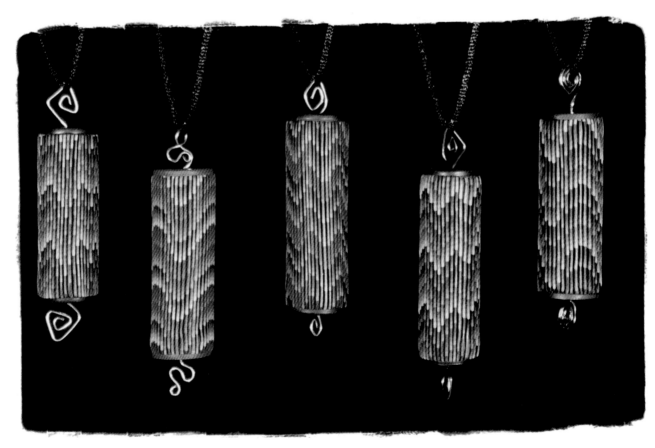

Linda Pederson
San Francisco, California

LINDA WAS A POTTER, who had been working in reduction-fired stoneware and porcelain for ten years, when she saw a window display of polymer clay in 1987. "I didn't know it came in colors and thought it might be fun to play with. At the time, I was doing a little fish design in porcelain with a cobalt glaze. I started to do the fish with polymer clay, and within two weeks I wasn't a potter anymore."

Besides the fish beads which she still makes, Linda incorporates bold canework into her signature pillow beads. Amish quilt makers and her graphic-art training are credited as the inspiration for much of her work. Linda feels that the traditional Amish colors and designs "out-dazzle."

Foods inspired a series of Linda's fun and whimsical pieces. When she works on a chocolate necklace, for example, she keeps a box of chocolates in her studio so she can carefully match their form, color, and surface texture. Small amounts of mineral oil added during the conditioning process softens the polymer clay's working consistency and foster the illusion of hand-dipped chocolates. Creating a necklace with the faux chocolate pieces is an unexpected surprise. Linda strings her beads on round elastic cord, which offers a textural match to the polymer clay and gives flexibility to the necklace.

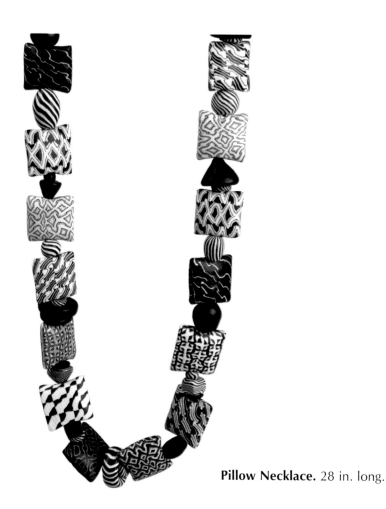

Pillow Necklace. 28 in. long.

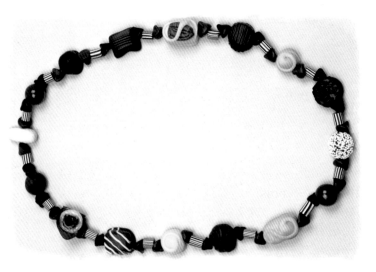

Candy Necklace. 28 in. long.

Jan Regent
Berkeley, California

"My focus changes a lot. I don't just work on one thing."

JAN DESIGNED jewelry with stone and seed beads for many years. While searching for a material that was less traditional and which would allow her to explore new approaches, she read about Kathleen Dustin's polymer-clay work in *Ornament* magazine. That article began a journey of discovery for her. Since then, Jan has also admired the work of Pier Voulkos and acknowledges Pier's influence on her own work.

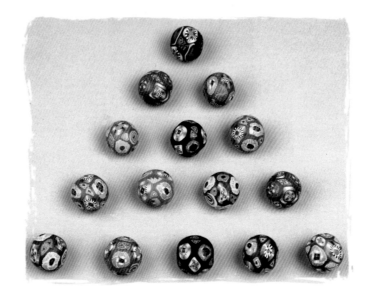

Millefiori Beads. Jan designed these beads to be used together. Carefully controlled color relationships and precise cane construction contribute to the visual impact of the beads. The stylized-flower canes used to create the beads was made in several different color combinations. Each 1 in. diameter.

Kelly Russell
Waveland, Mississippi

"I don't like to stick to one thing and love to experiment."

CARVING INTO polymer clay reminds Kelly of carving linoleum-printing blocks, except that polymer clay is much cleaner and she can adjust areas when she is not happy with the results. The surface decoration on her boxes and vessels was created in several stages. Each piece may be fired as many as six times. The layers of color under the surface are revealed when she carves portions with linoleum carving tools. Kelly backfills some areas with polymer clay after carving them, thereby creating the illusion of depth. Before the final firing, she sands the entire surface.

Detail of Flying Petro Vessel. 5 in. x 5 in. x 12 in.

Milene and Rudi Sennett
Cape Province, South Africa

"My personal creative philosophy centers on the belief that everything interconnects in some way, that there is some universal denominator. I see it in the manifestation of the structure in design. Call it rhythm or patterns if you will, that which influences everything." -R.S.

WHILE DOING research for her Master of Fine Arts degree, Milene became interested in ancient beads, particularly African trade beads. Rudi's background is in graphic art and he shares Milene's passion for the unique designs on trade beads.

Milene and Rudi began working with polymer clay in 1986. Initially, they concentrated on making beads. Rudi designed and produced beads while Milene designed necklaces, hunted for components and ran the business. Rudi felt limited by the form and design of beads as he became more proficient with polymer clay. His frustration with the bead form led to the creation of Bonga Mosaic Miniatures. The name, Bonga, is a Xhosa (an ethnic tribe in the Eastern Cape Province, South Africa) word that means "an offering."

They now use the cane plaques exclusively in their jewelry instead of beads. To create the necklaces, Milene strings cane plaques with locally available materials, such as ostrich eggshell beads. She dyes the eggshell beads using dyes made from local plants.

Their millefiori cane designs are based on animal motifs and ancient designs. The cane plaques include great detail, sometimes repeating the pattern of the main image in the border. Many canes are constructed using a combination of opaque and translucent polymer clays. Rudi and Milene make canes on a large scale and have used up to 77 pounds of polymer clay to construct one loaf!

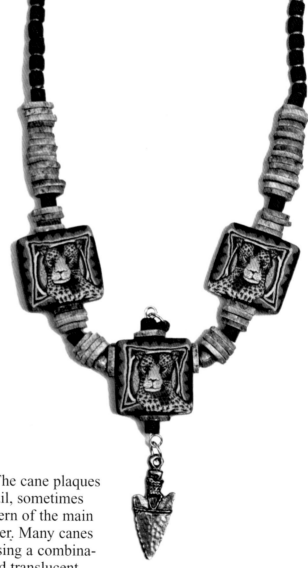

Leopard Necklace. The polymer-clay plaques on this necklace are strung with ostrich-eggshell beads. 19 in. long.

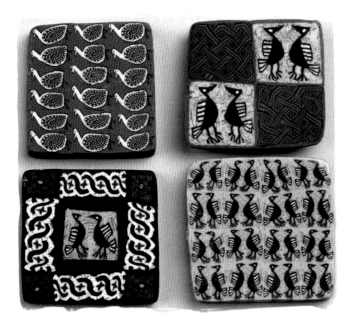

Guinea Fowl and Birds Pins. Each 1.5 in. x 1.5 in.

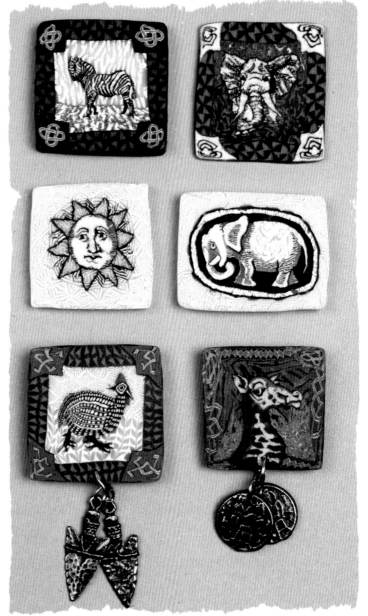

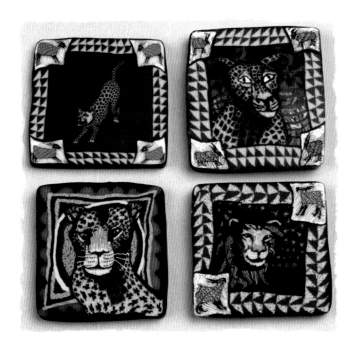

Leopards and Lion Pins. Each 1.5 in. x 1.5 in.

Zebra, Sun, Elephants, Guinea Fowl, and Giraffe Pins. Each 1.5 in. x 1.5 in.

If you hit a blank, do you have a ritual that helps you start working again?

I wait for the muse to strike me again. Sometimes it can take forever.
-Jamey Allen

I just start kneading. The feel of polymer clay is inspiring to me.
-Melissa Brown Bidermann

I do color mixing, no designs; or I make tons of bead-size balls from my sludge box to be covered later.
-Pat Berlin

I go for a run around the duck pond.
-Martha Breen

A trip to the drug store with a long stop at the greeting card area usually gets me more motivated than I can handle. There are marvelous patterns and faces on greeting cards.
-Maureen Carlson

I have really never had a blank. I am a disciplined person and can make myself just get on with it.
-Michele Fanner

We mix piles of color. It's very physical and when one is feeling stupid, it's the best thing to do.
-Steven Ford

I begin to play around with the material. Often I fiddle with a little polymer clay and slowly I begin to forget my expectations about what I "should" be doing and begin to remember why I like doing this.
-Michael Grove

I walk away, let my mind wander, or work in the garden.
-Diane Keeler

Ileen Shefferman
McLean, Virginia

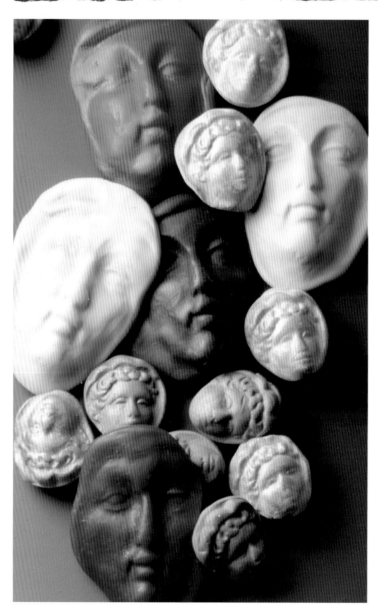

Press Molded Brooches and Button Covers. Ileen uses a combination of ceramic and polymer-clay molds. After removing the faces from the molds, she altered them slightly to give each a unique character. Acrylic interference paint gives an antiqued look to the finished pieces. Brooches: each 2.5 in. x 3.5 in. x .5 in., button covers: each .75 in. x .5 in. (Photograph by Chris Roche.)

When I am blocked, I go see exhibits of artwork in different media (e.g., quilts, portraits, etc.). Usually, this helps me look at my work from a different perspective.
-Christie Leu

I don't get stuck. My frustration is having too many choices, or going off on too many tangents. To me, getting stuck, is a symptom of not having enough trust in your personal way of working, in your discernment of what's important, and of not allowing yourself to be the actor in your own life. Do not give authority to someone else.
-Tory Hughes

I have so little time for my work that I'm usually thinking about what I will do next. I keep a sketchbook in which I write down thoughts, inspirations, etc. I go back to it for ideas if I am "stuck."
-Barbara Morrison

If I get stuck, I go for coffee, go to a movie, play with the fish, or do the dishes. Sometimes all it takes is getting away from it for a few minutes.
-Linda Pedersen

I usually do something active, like take a walk or go to the gym. Removing myself from the work completely seems to help.
-Ileen Shefferman

After all these years in the studio, I've come to expect that there will be times that I feel "stuck" for what to do next. Sometimes doing something else for a while helps. Then when I come back to it, I can see the problem more clearly.
-Jeanne Sturdevant

I sit and mix new colors, a slightly mindless task that keeps my hands busy and lets my mind wander.
-Pier Voulkos

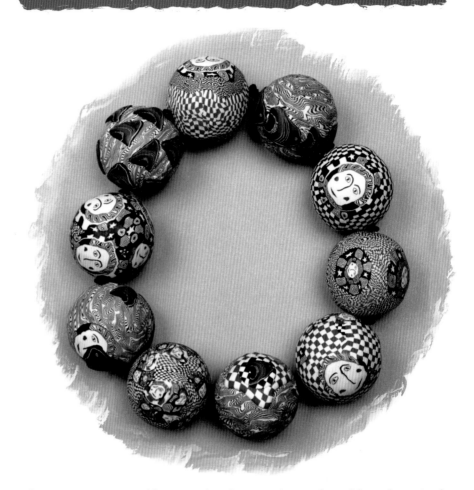

Fish-Face Ping-Pong Necklace. Carol's solution to the weight problem of oversized beads was to cover table-tennis balls with polymer clay. 18 in. x 1.75 in.

No blanks! Just the opposite. I need more hours in the day for all the ideas I have, especially when I am on a caning binge.
-Jewel Lewis

I just try to keep going through the low points. Sometimes switching mediums helps, but I have found that if I keep working, even if it is on miserable stuff, the slump is shorter. If I stop working, I get jammed, and it is hard to get started again. I try to have faith in myself. I developed this approach when I was an art director; the business world does not care if you are in a slump. You have to keep

producing. I try to think "professionally" at all times. It helps.
-Laura White

I collect clippings from magazines and a sketch book. When I think of an interesting idea, I jot it into my journal. Then, when I "hit a blank," I go through my clippings' folder or my journal (which I carry everywhere) to search for inspiration. I also love visiting folk-art stores and Seattle Museum's African Art Collection, going through books or magazines, and discussing ideas with Dan, my husband and partner in beads.
-Cynthia Toops

Sarah Nelson Shriver
San Rafael, California

"I am a pattern person. In many ways my imagery is secondary. For example, I could use just a dot and a square as a graphic component and continue to arrange them in different ways and that could go on forever."

SARAH CONTINUED to explore her fascination with patterning and costume design after completing her B.A. degree from the University of California at Davis. Her familiarity with surface design, textile analysis, and pattern making is evident in her work.

In 1988, Sarah saw one of Martha Breen's necklaces and that motivated her to start working with polymer clay. She describes herself as an artist who became an "instant addict" after her initial exposure to polymer clay. Now, she runs her own polymer-clay-button and bead-design business.

Sarah considers her canes of faces, stickmen, and fish bones to be graphic components in her complete designs, but she is aware that people may identify the Egyptian and African influences in some of her imagery. When asked about the symbolic meaning of her signature fish-bone cane, Sarah explains that it was an attempt to create the graphic inverse of an arrow cane.

Many of her canes are constructed on a large scale, using up to ten pounds of polymer clay. While she creates most of her work in black and cream, she sometimes uses red as an accent color. Occasionally, Sarah includes purple, turquoise, and green in her canes.

Fish, Fish and Men, and Face Orb Pendants. 1.5 in. diameter, 1.75 in. diameter, 1.5 in. diameter.

"I try to experiment a lot. I let metamorphosis follow the direction that seems to be working best. The pendants started as components of candle holders and I liked the shape."

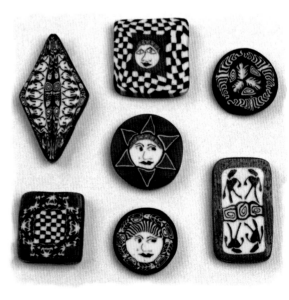

Buttons. Each approximately 1 in.

Mary Jane Sirett
London, England

"My studio has good lighting and a view of the London skyline to exercise my eyes after a lot of close work."

MARY JANE BEGAN working with polymer clay one rainy day in 1988. She had no preconceived notions about how to use it, since she had not yet seen anyone else's work. She started experimenting and playing with it. She found that her work was being inspired by Lalique's jewelry designs, Bosch's wonderfully bizarre paintings, the curvilinear lines of Gaudi, and the work of the surrealists. Masks are a recurring theme in much of her work. Besides polymer clay, Mary Jane incorporates other materials into her work, such as cast-pewter charms, coral, and glass. To accentuate the organic feeling of her pieces, she often uses champagne-colored polymer clay as her mixing white. She assembles cane slices to create each piece, allowing spirals to elongate and coaxing stripes into gentle curves. Often her pieces are three-dimensional collages of cane slices.

Mask Pendant. This pendant combines polymer clay with glass beads. 5.5 in. x 4 in.

Brown Pin. (right) Mary Jane made this pin with slices of polymer-clay canes and a cast pewter charm. 4.75 in. x 2.5 in.

Orange Pin. (far right) Polymer clay and a glass bead were used to create this pin. 2.75 in. x 1.75 in.

53

Wilcke Smith
Albuquerque, New Mexico

"The fine craftsmanship we try to achieve, the techniques and processes we use, are important only to the degree that we can translate our ideas into forms of art."

Eₐᵣₜₕ MOTHER SHRINE, Wilcke's first polymer-clay piece was completed in 1987. Earlier pieces featured birdlike figures with needlelace and wrapped fibers. She cannot recall a specific influence that caused her to switch to polymer clay; she simply envisioned a smooth figure surrounded by fiber. The idea of the contrasting textures excited her; so she started experimenting with polymer clay and was converted.

Wilcke finds polymer clay enormously expressive. It does almost anything she can dream up and, in comparison to stitchery, is very fast. This allows her many design options.

A large part of Wilcke's artistic process is combining old and new images in her mind to see the possibilities for a new work. "Ideas are often reflections of our own pasts; they grow out of dreams, experiences, the need to share feelings, to communicate, and to say something uniquely personal."

After envisioning a work, Wilcke makes dozens of thumbnail sketches, scribbles notes, reworks the drawing, and then finally enlarges the sketch to full scale. Revisions to the full-scale drawing may be made before she begins either the fiber or the polymer-clay portion, depending on her

schedule. The integration of fibers and polymer clay is a challenge Wilcke enjoys.

Influenced by a strong attraction to the techniques and imagery of ancient cultures, Wilcke's travels

to Mexico, Peru, and Ecuador have enhanced her reflections on the rich artistic traditions of the Southwest where she lives. Many of her ideas emerge from prehistoric symbols, elusive graphics, and mythical characters.

Moon Wraiths II. Wilcke used polymer clay on a wool twill background with thread, lace, gold foil, bead eyes, and a gouache wash to create this piece. 14 in. x 11 in. (Photograph by Wilcke Smith.)

Quest II. (previous page) This piece was made with polymer clay combined with paper, crayons, lace, metallic thread, copper nugget, mica disk, and bronze powders. 12 in. x 9 in. x 1.13 in. (Photograph by Wilcke Smith.)

Jeanne Sturdevant
Greenville, Texas

"Art is my personal vehicle for telling the world who I am."

JEANNE TRIED polymer clay at the urging of a friend in 1988 and immediately began a voyage of new discoveries. It has taken several years of working with polymer clay for her to feel that she has attained sufficient experience to express herself accurately. She says her work is more about "feeling" than "fact." As such, the images her pieces evoke are elusive and her titles suggest, rather than define, the piece.

An exploration of the vessel as an artform began when she felt confined by smaller pieces. Her vessels are meant to be enjoyed as sculpture and are not intended to be functional. They stand alone with clarity and force.

Day at the Beach. Jeanne created this vessel by layering polymer clay and then slicing it to expose the opposing color. 10.5 in. x 4.5 in.

Animated Conversation. Layers of black and white polymer clay were wrapped around a form to construct this vessel. 4.5 in. x 4.5 in.

Lynne Sward
Virginia Beach, Virginia

"The best things in life are not things."

LYNNE IS AN accomplished fiber artist who incorporates the many techniques and sensibilities that she uses with her fiberwork into her polymer-clay jewelry. For example, several of her polymer-clay designs are collages of striped and spiral canes. Her color combinations, and the rhythm of the pattern-repeats, take precedence over the complexity of the individual millefiori canes she uses. Lynne constructs her polymer-clay jewelry much in the same way that she adds bits of thread, pattern, or trim to her fiberwork.

Many contemporary fiber artists embrace technological advances, and in this regard Lynne is no exception. She often uses photocopies in the conceptual, design, and execution stages of her fiberwork and her polymer-clay jewelry. The reduction and enlargement features of photocopy machines allow for changes in scale of fabric patterns and other playful experimentation with images. Lynne transfers photocopies of fabric and other images onto polymer clay and then combines the images, fabric, polymer clay and other materials to create unique pins.

Mola Shirt Pin. (above) A blend of black-and-white photocopies and color laser copies was transferred onto this polymer-clay shirt pin. 2 in. x 2 in.

Dragon Lady Pin. (right) In addition to polymer clay and color laser copy transfers, Lynne used small bits of metallic leaf to create this pin. 1.25 in. x 3 in.

Gemini Pin. (right) Lynne combined fabric and photocopy transfers with polymer clay in this pin. 1.75 in. x 1.75 in.

SAM FIRST experimented with polymer clay in 1979, "just for fun," but began using it again in 1990 with more serious motives. She trained as a painter and tends to take a "painterly" approach with her polymer-clay work. The color-mixing properties of the material intrigue Sam and close examination of her canework reveals the subtle color-mixing technique she uses to achieve the illusion of three dimensions. Each color is a combination of several different colors, but they are not completely blended.

Sam's main focus with polymer clay is bead making. She works with her partner, Dave Allender, and her daughter, Gina Senzatimore. She says it is great to be able to work with others and to share ideas.

Cactus Flower Dish. 5.25 in. diameter.

Cynthia Toops
Seattle, Washington

On A TRIP TO Hong Kong, Cynthia discovered polymer clay. Her sisters were using it to make jewelry and this motivated Cynthia to begin making jewelry incorporating simple quilt designs. Her work since then has become increasingly more detailed and intricate.

Cynthia received her B.F.A. degree from the University of Washington, where she concentrated in printmaking. Polymer clay was an attractive alternative to printmaking for her, since solvents are not necessary with polymer clay. While she has done some printing with carved polymer-clay stamps, her current work varies between millefiori canework and a unique "micro-mosaic" technique. Many of Cynthia's necklaces require months to complete due to the large variety of canes used within one piece. One of her pendants for example, included 250 cane slices!

At first glance, Cynthia's "micro-mosaic" beads appear to be made of bugle beads. Actually, they are constructed from hundreds of pre-fired polymer-clay pieces. The starting point for these beads is often a color that excites Cynthia. For the bluebird beads, she started by mixing a dozen different blues ranging from deep violet to pale turquoise. She rolled the polymer clay into pencil-lead-thin cylinders, fired the pieces, cut them into small bugle-bead shapes, and laid them on a polymer-clay base with forceps. A final firing secured the mosaic pieces in place.

People Beads. These polymer-clay beads are made with a combination of canework and onlay techniques. They are reminiscent of painted nesting dolls in look, shape, and ethnic flavor. Each .75 in.

Each bead design involves extensive research, sketching, and mental planning. The research and planning stages sometimes take longer than the actual construction work. Cynthia begins work with polymer clay after she makes numerous sketches of potential arrangements of images, shapes, color possibilities, and sizes of the bead. As the work progresses, she may adjust the original design and sometimes she takes portions apart and reworks them. Cynthia has spent up to 40 hours completing one "micro-mosaic" bead.

There are many influences on her work but she credits the following artists as among those who inspired her: Vincent Van Gogh, for his enthusiasm, energy and dedication; Alden Mason, for his textures and colors; Glen Alps, for his energy and innovative spirit; and her father, for his willingness to experiment with new media.

Long Sunflower Bead. (left)
Hundreds of tiny, polymer-clay
pieces are laid on the surface with
forceps to create this mosaic bead.
8.75 in. x 1 in.

Sunflower with Bluebirds Bead.
(right) Each mosaic bead involves
many hours to plan and construct.
Collectors sometimes wait months
to have one of their own.
2.38 in. x 1.23 in.

How do you know when a piece is finished?

Some pieces are never finished, especially necklaces. I restring some necklaces numerous times because I come across a new exciting bead to add. Sometimes I make different versions of the same object by changing the color, the placement of shapes, the shape of the bead, etc., and by using different designs or images. A lot of "knowing when something is finished" is instinctive.
Cynthia Toops

Ah! An interesting question. I'm not always the best judge of when a piece is finished. Sometimes I need help deciding. My husband (my strongest patron, though not an artist himself) supplies me with valuable feedback on request. Other times I have to walk away and come back later to see a piece clearly, deciding then what it needs or if it is finished.
Jeanne Sturdevant

I believe in quitting while I am ahead, and in not overworking something.
Jamey Allen

Guesswork. I have no hard-and-fast rule for this. Sometimes I intend to make a larger brooch then start trimming, evening up, etc., and end up with a tiny pair of earrings.
Pat Berlin

When it says something to me that I think the viewer will be able to feel as well.
Maureen Carlson

This is the hardest question that I face on a daily basis. It is done either when it looks right to me, or when I am sick to death of it and never want to see or touch it again, ever. When the latter happens, I throw the piece in the ocean, truly. I have a special spot on the beach for this. Someday, I hope to find the ruins of a piece, changed from being tumbled in the sand.
David Edwards

I try to stop before I have gone too far.
Robin Kimball

A piece is done when it smiles at me, and I see something unexpected and true.
Tory Hughes

When it is so overloaded with stuff that I have to stop. Although I don't sketch a plan on paper, I usually know what I want a piece to look like. When it feels like that, I stop.
Barbara Morrison

Something clicks. I don't know exactly, it just feels right and an inner voice says, "Stop, that's it."
Linda Pedersen

A piece is finished when it looks right. This is a completely intuitive decision, one that partners don't always agree upon.
Steven Ford

We say, "This piece is finished," and it is, unless we do something else to it!
Michael Grove

I often go back to a piece, after I've lived with it for a while. It is always valuable when you have gone too far, the learning process is much richer.
Liz Mitchell

A piece is finished when, if I do any more, I will be hurting the piece instead of helping it.
Barb Wagley

When my intent is reached and the next piece starts to call me.
Martha Phelps

It conforms to my initial concept and full-scale drawing, and is as good as I can possibly make.
Wilcke Smith

I've often taken pieces apart and used the components in new pieces; so I guess you could say I have no idea when a piece is really finished. Perhaps when it is sold and gone. I do not lose any sleep over it then.
Laura White

Heart Pin. *Pierrette Brown Ashcroft.* 1.75 in. x 2 in. (Photograph by Jerry L. Anthony.)

Pier Voulkos
Oakland, California

"When I am making a piece of jewelry, I try to make something that reads well, works as a whole, and is comfortable to wear."

ARTISTS AND ARTWORK have always been a big part of Pier's life. Her father, Peter Voulkos, is a well-known ceramicist and sculptor, and her mother, Margaret Voulkos, is a ceramicist and craft teacher. As a young child, Pier was always encouraged to experiment with different forms of artistic expression in both the visual and performing arts.

Pier changed her focus after graduating from California College of Arts and Crafts with a B.F.A. degree in ceramics, and began dancing with jazz choreographer, Ed Mock. Her dance career took her to New York City where she both danced and designed sets and costumes professionally for nearly a decade.

Pier first used polymer clay in the late 1970s, but most of her time then was devoted to dance. In the mid 1980s she designed a series of necklaces with plastic figures as the focal point, and used polymer clay to create beads resembling candy canes that related visually to the figures.

Pier reluctantly retired from dance in 1991 and became a full-time polymer-clay-jewelry designer. She prefers to concentrate on color and pattern relationships, rather than making complex canes. It is interesting to see the massed cane slices in Pier's necklaces and, on closer inspection, to dis-

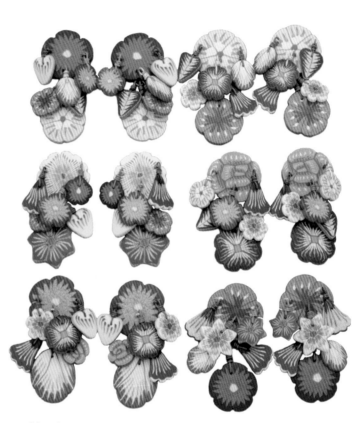

Double Flower Earrings. Slices of flower canes are suspended from plastic-coated wire hooks. Each 2.5 in. long. (Photograph by George Post.)

cover that each piece deserves individual attention.

Much of Pier's jewelry utilizes cane slices as design elements and these slices are not laminated onto other surfaces. This allows the viewer to see that the image runs through the bead, adding to the wonder and excitement of her jewelry.

Most of Pier's canes are made as part of a series. A common theme,

such as seashells, flowers, or unique color combinations, provides the linkage in her work. Though a jewelry series may be created from the same canes, Pier arranges each piece differently, thereby making each one unique. Even her most popular earring styles are fashioned one at a time and each pair is different. She works with a cane series for up to six weeks to create earrings, bracelets, and necklaces, and then

she will move in a new and different direction.

An experiment with large pieces that are light enough to wear, led to a whole series of kinetic jewelry. Pier had already embedded hooks in her pieces, so in an inspired moment, she decided to hang cane slices on the hooks. The result is a series of *Chandelier* earrings, bracelets, and necklaces that incorporate slices of canes hung on plastic-coated wire hooks.

As she moves from one series to another, Pier fires extra cane slices and saves them for future use. When the box containing cane slices is full, she accesses the contents and then makes additional canes to "pull the others together" and "punch up" the color combination. The *Fancy* necklace and earrings are a delightful record of a year's worth of her canes.

Many of Pier's color mixes contain little dabs of different colors. When mixing a new color, she usually combines a range of values within the same hue. Since she does not always completely blend her colors, small specks of the mixing colors are still visible. While Pier has taken several classes on color theory, most of her color decisions remain intuitive.

"What is really great, with so many artists working in the field now, there is a lot being explored and I can learn from things that other artists have tried."

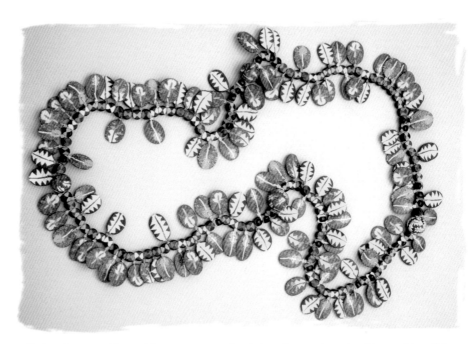

Fall Feather Necklace. There was much trial and error involved in making this colorful necklace. Pier first selected her color palette, then made a conscious effort to pick an accent color that she normally would not use. Because of the scale of the piece, the viewer's eye mixes the colors. 36 in. long. (Photograph by George Post.)

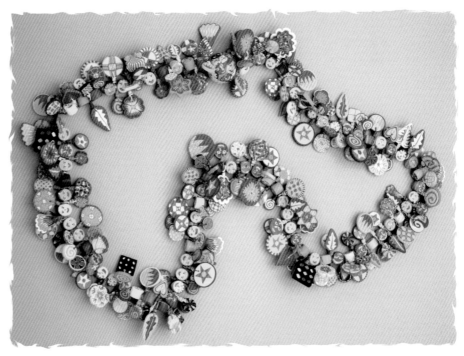

Fancy Necklace. Pier saved cane slices until she had enough to make this necklace. She has been known to string and restring a piece three or four times until it feels "right." 32 in. long. (Photograph by George Post.)

Pier Voulkos

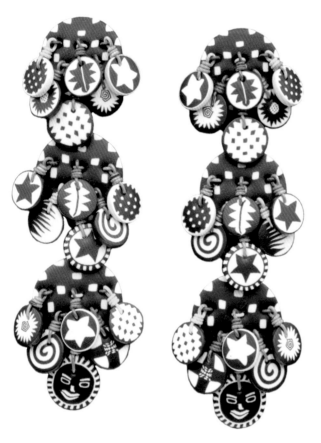

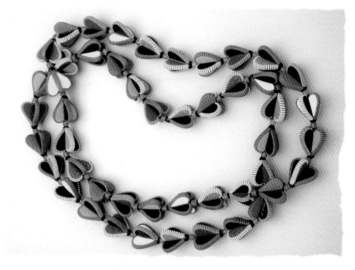

Lantern Necklaces (2). Each bead is created from thick cane slices attached to a polymer-clay cylinder. The result is a unique bead shape. Individual beads: 1.25 in. x 1.25 in. (Photograph by George Post.)

Triple Black and White Harry Earrings. There are three levels of cane slices on these earrings. 3.75 in. long. (Photograph by George Post.)

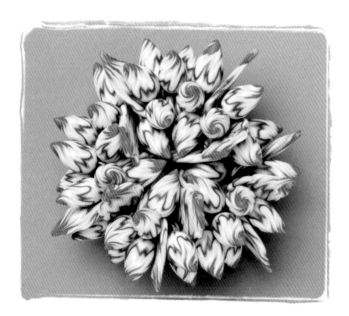

Campfire Braclet. (Photograph by Martin Zeitman.)

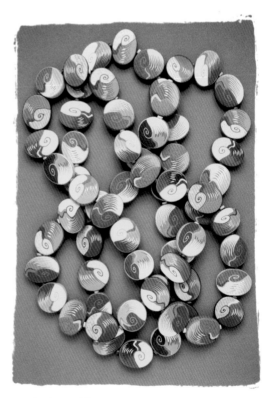

Spiral Necklaces (3). Each 33 in. long. (Photograph by George Post.)

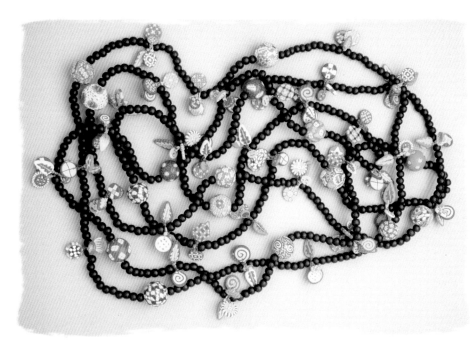

Black Seed-Bead Necklaces (4). 32 in. to 36 in. long. (Photograph by George Post.)

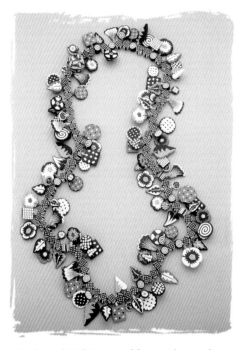

Black and White Necklace. This polymer-clay necklace was an exploration of shape, tone, and value without having to think about color choices. 34 in. long. (Photograph by George Post.)

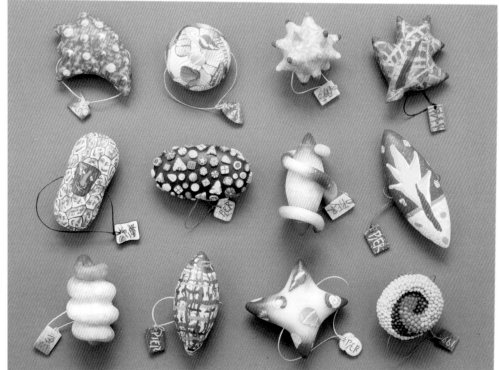

Twelve Beads made for the 3rd International Bead Conference. (Photograph by George Post.)

Barbara Wagley
Sioux Falls, South Dakota

"I try to make my dolls look like real people with whom we all can identify, and hopefully bring back some fond memories of someone we know and from whom we have gathered wisdom. These are not beautiful dolls, but dolls with the lines of time. I chose the name, Faces of Wisdom, for my dolls because beautiful people are not always wise, but wise people are always beautiful."

BARBARA STARTED working with polymer clay in 1989. She was inspired by the polymer-clay dolls of Robert McKinley and Anne Mitrani at the time. Although she is mainly self-taught, she feels that workshops with Jack Johnston and Maureen Carlson have influenced her work.

Barbara especially enjoys working with polymer clay because she can start a piece, let it set for a while, and then come back to continue working on it without having to worry about it drying out as natural clay would. This unique property allows her to work on several pieces at a time. The responsiveness of the polymer clay is one factor that helps her to impart character to her dolls.

Quilter. A foil armature adds structure to this polymer-clay figure. 7 in. tall.

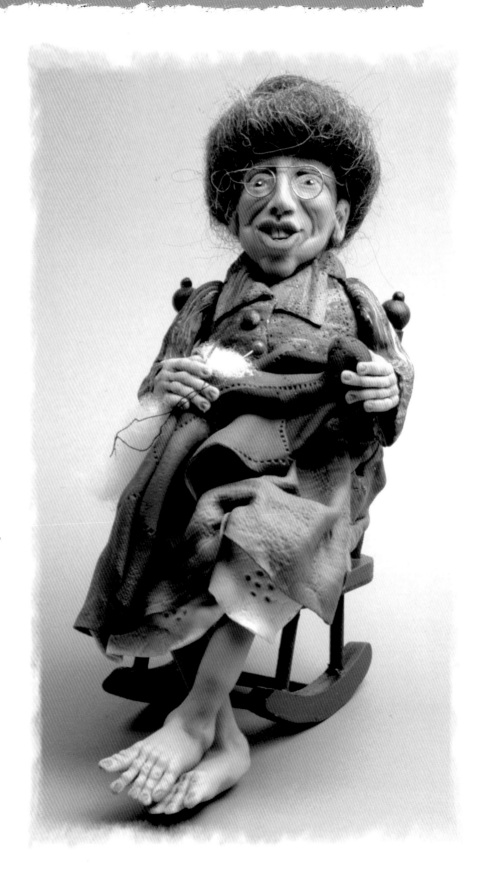

Carol Walker-Morin
Springfield, Vermont

"When people follow what they are drawn to, and can make something from that inspiration, it will inspire others."

In 1987, CAROL was graduated from the Rhode Island School of Design with a degree in sculpture. A fellow artist gave her polymer clay as a gift and Carol experimented with it on her own for several months. An exhibit of Sarah Nelson Shriver's work at a local gallery further inspired Carol, and now she works full time designing polymer-clay jewelry.

Sun Pin 2.25 diameter
Moon Pin. 2.25 diameter

Interest in ethnic and primitive art has influenced Carol's cane images. She developed her interpretation of the Egyptian symbol, Eye of Horus, which is represented by the sun and moon. Lunar and solar images are frequently used symbols in her work.

Much of her jewelry incorporates basic canework such as stripes, spirals, and stars into the complete design. Carol cuts the basic shape of a pin from a sheet of polymer clay and then she outlines it with a contrasting color of polymer clay. To this piece she adds embellishments such as subtle, three-dimensional, surface designs. Small bits of custom-mixed colors of polymer clay are played against the patterned canes to add definition. She avoids "visual clashes" by lightening the value of one of the colors when she uses complementary colors. The process Carol uses to create her polymer-clay jewelry is similar to drawing.

Bird Pin. 1.5 in. x 2.88 in.
Star Braclet.

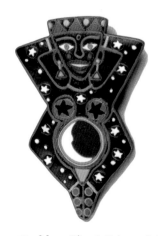

Bird/Snake Face Pin. 2.13 in. x 2.38 in.

Lounge Goddess Pin. 1.5 in. x 2.25 in.

Ellen Watt
Providence, Rhode Island

"Don't just appreciate it, wear it."

Ellen's COMPREHENSIVE and varied background in the arts includes costume design, arts administration, teaching, and writing. She started working with polymer clay in 1988 and delights in its color, its ability to hold detail, and its clean texture.

Iridian Faces. These figures combine polymer-clay heads with seed beads, plastic mesh, and pipe cleaners. Each head 1 in. x 2 in.

Jane Woodside
San Francisco, California

"I see myself more as an artisan than an artist, since I am expressing possibilities of the medium, not using the medium to express any hidden truths about life or the world."

JANE WAS FIRST exposed to polymer clay when she tried to buy some beads from a window display. The beads were not for sale, so she bought a few bars of polymer clay to make her own beads, and, like so many others, was immediately captivated. Interestingly, Jane is a full-time business attorney, using words to express her creativity. She finds working with polymer clay to be a refreshing alternate form of expression.

Night Mask. Jane combined surface texturing and modeling to construct this mask on a plaster form. The metallic powder was applied before the mask was fired. 6.5 in. x 4 in.

Laura White
Rochester, Vermont

"What I like most about the medium is its blandness of character. What pieces end up looking like is almost totally up to the artist and it can look like anything, except perhaps, glass."

Laura's EDUCATIONAL background is in fine arts, but she worked in graphic design for 15 years, as an art director for two advertising firms and a greeting card company. Her interests in the arts include printmaking, photography, illustration, and silk painting. In 1991, Laura seriously began working with polymer clay. Today, she works full time with polymer clay and painted silk.

Laura draws on her knowledge of how colors react in the printing process as she mixes her polymer-clay colors. For primary colors, she chooses magenta, light turquoise, and yellow, to which she adds a small amount of white to counteract the darkening effect that can occur during firing. The changing seasons in Vermont influence her color choices. She likes to watch the greens of summer change to the reds and golds of autumn.

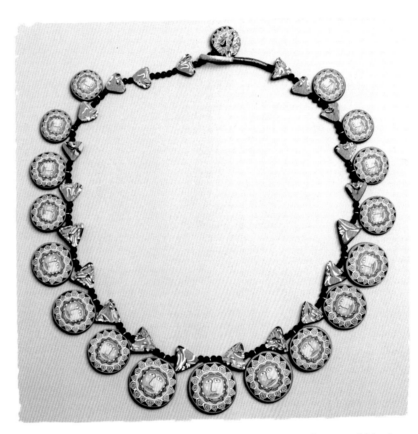

Face Disk Necklace. A graduated series of face-cane slices and black onyx beads are strung on rattail cord. Scraps from the end of face cane were used to fabricate the complementary triangle-shaped beads. 26.5 in. long.

Cat Pendant. (right) Laura merges millefiori canes and metallic paint on this pendant. Small areas of the black polymer clay were incised before being fired. Metallic paint applied to the surface was later sanded off and remained only in the areas which were incised. Pendant 3.5 in. x 3.5 in.

Fractured Face Pin. (left) Partial slices of a face cane combined with gold leaf create an interesting effect on this pin. 2 in. x 2.25 in.

69

Elise Winters
Haworth, New Jersey

"My love of fine Japanese handcraft and folk art surfaces as a strong influence in this series of polymer-clay fan pins. The pieces also reflect my fascination with handmade paper. A translucent quality in some of the fans harkens back to my earlier ceramic experimentation with light and paper-thin translucent porcelain."

ELISE'S LIFE has not been the same since she took her first polymer-clay workshop. For the first year her dining room table was covered with work in progress. Now, she has a dedicated work table in an adjoining space and is again able to invite friends over for dinner. There are still nights when her husband has to drag her to bed at 3:00 a.m. Since she teaches full time she has to fit creative time in when she can.

The first time Elise saw Pier Voulkos's work she felt a great rush of excitement. This new medium gave her an opportunity to experiment with new techniques. Elise became fascinated by the ways in which it took texture and how it folded, twisted, and draped. She was also struck by the possibilities of exploring color mixture and for playing with a myriad of subtle color combinations with millefiori.

Elise feels that it is an exciting time to be working with polymer clay. "This medium holds so much potential with so few traditions. Each day I discover ever-expanding possibilities and new paths for pushing polymer clay to its limit."

Fan Pin. The fan format affords an opportunity for Elise to experiment with inclusion and decoration including fibers, metallic powders, photo transfers, and carving. Fan 2.38 in. x 4.38 in. (Photograph by Peter Fornabai.)

Fan Pin. The struts are riveted together and are moveable before they are glued to the polymer-clay fan. Fan 2.38 in. x 4.38 in. (Photograph by Peter Fornabai.)

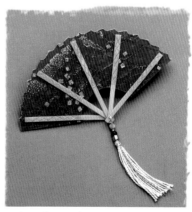

Fan Pin. Elise's thin translucent fan pins combine polymer clay with struts made of faux ebony or ivory. Fan 2.38 in. x 4.38 in. (Photograph by Peter Fornabai.)

Appendices

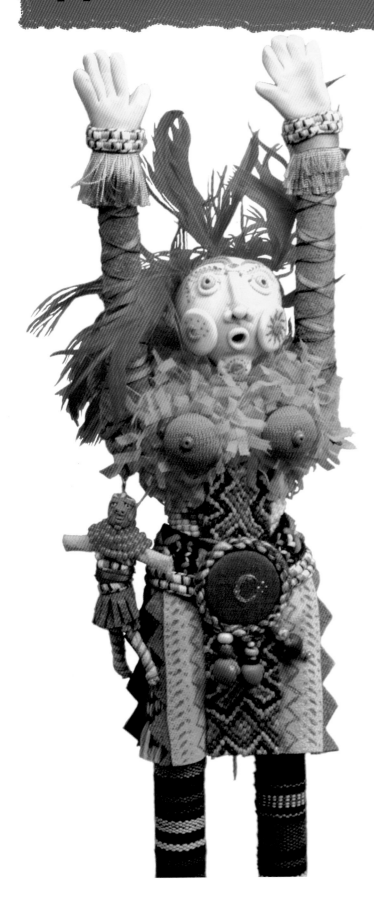

Votive Figure. *Barbara Morrison.* 12 in. tall

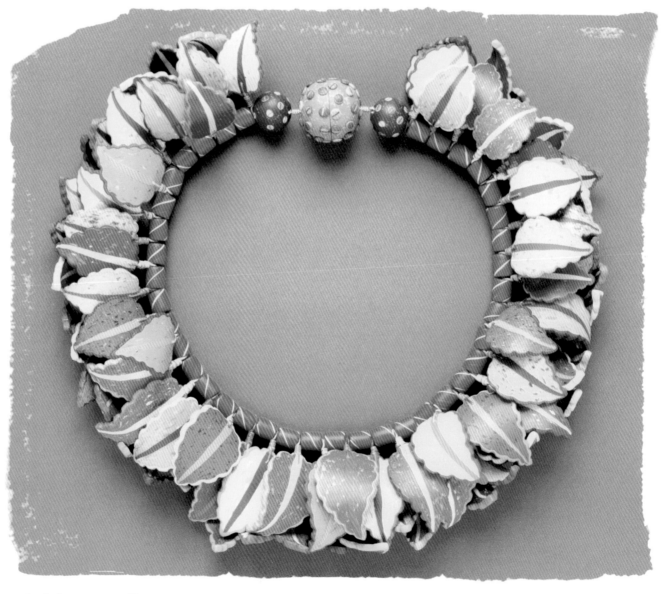

Curled Leaves Necklace. *Pier Voulkos.* 18 in. long. (Photograph by George Post.)

Definitions

WE HAVE DEFINED some terms in this book that may not be familiar to everyone in the context in which we use them.

Canework: This glassworking term refers to the process of bundling colored-glass rods to create a pattern. Polymer clay artists adopted the term to refer to a similar technique. *Canes* are usually round, bundled designs of polymer clay. Square or rectangle bundles of polymer clay are usually called *loaves*.

Conditioning: This refers to the process of manipulating polymer clay to attain a workable consistency.

Firing: The application of heat to polymer clay transforms it to a permanent state. We have deliberately chosen this term, to align this medium with the process appropriate with permanent products.

Medium: is any material used for expression or delineation in art. For example, painters may choose acrylic or oils as their medium and ceramists may use stoneware or porcelain. Many artists use more than one medium to create their art.

Millefiori: This is an Italian term literally meaning "a thousand flowers." Venetian glassworkers coined the term, but the origins of the technique are believed to go back to 300 B.C. in both Egypt and Rome. Colored-glass canes, or rods fused with heat, form ornamental designs. The canes are then

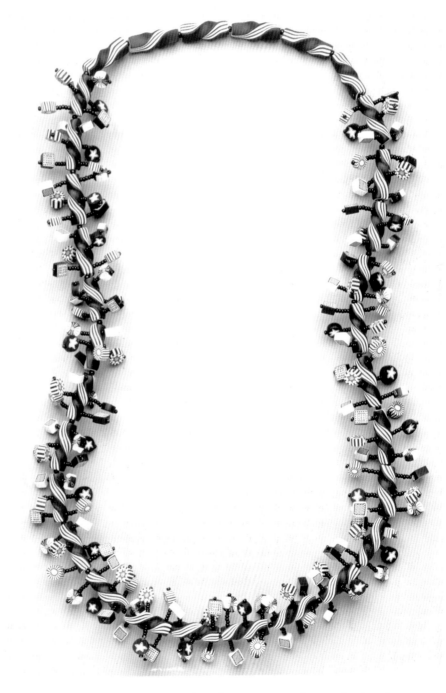

Helix Necklace. *Pierrette Brown Ashcroft.* Over 300 polymer-clay beads spiral around this necklace. 32 in. long. (Photograph by Glenwood Jackson.)

sliced crosswise and applied to other surfaces such as beads. The caning technique is also used with ceramic clay, but we are usually referring to this technique as it applies to cane construction with polymer clay.

Mokume: This is a Japanese metalwork term, literally meaning "wood grain." Similar effects can be achieved by stacking different colors of polymer clay in layers of varying thickness. Pieces of polymer clay placed under the stack raise some areas so that when thin layers are cut from the top of the stack, they will resemble wood grain.

Neriage: Different colors of clay (such as porcelain) are layered, cut into sections, and then pressed into a mold to produce the final piece. Neriage is sometimes called a clay mosaic.

Onlay: Pieces of polymer clay can be laid on the surface of another piece of polymer clay. The top pieces can be left in relief to add texture or they can be burnished or rolled between your hands to create a smooth surface.

Polymer Clay: A plastic, modeling compound available in many brilliant colors and metallic tones and varying translucency. It remains in a pliable state until fired.

We feel the two words together best describe the material. "Polymer" refers to a substance made up of giant molecules formed by polymerization. "Clay" is firm, plastic earth used in making pottery, but also means a substance that resembles clay in plasticity and is used for molding and modeling.

We have decided not to use the brand names of polymer clay. Each brand has some different properties and many artists have deliberately chosen the brand(s) they use for specific reasons. If we had written about another medium, such as oil painting, we would not have referred to the brand of paint used, though there may be similar decisions involved in selecting the material.

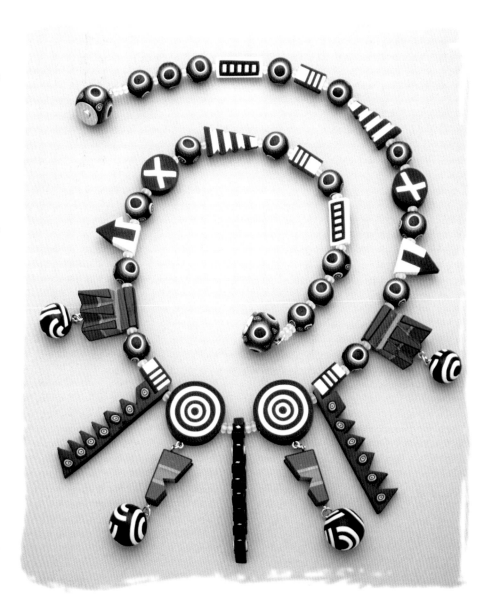

Zigzag Necklace. *Michael Grove and Ruth Anne Grove.* 21 in. long. (Photograph by George Post.)

74

Artists' Listing

Jade Vessel. *Tory Hughes.* This vessel is an assemblage of several separate translucent pieces that required multiple firings. The highly polished surface adds to the illusion of jade. 8 in. tall.

Ella Box. *Martha Phelps.* Martha's dog, Ella, served as inspiration for this polymer-clay box. 3 in. x 3 in. x 3 in.

Egg, Box and Brooches. *Margaret Maggio*. Egg 2.5 in., box 2.5 in diameter, brooches, 2.75 in. diameter, 1 in. diameter. (Photograph by Chris Roche.)

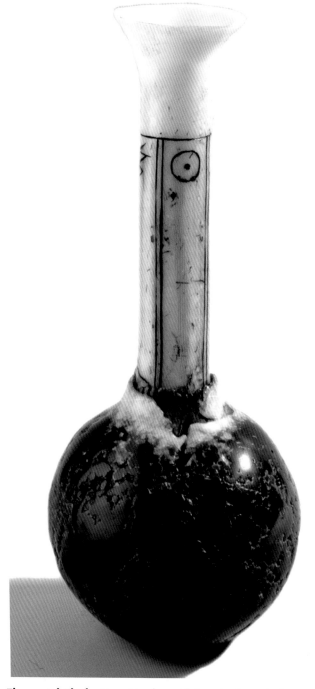

Elemental Flask. *Tory Hughes*. Alchemical symbols are incised on the flask. Tory chose the colors to represent air on the top and the earth on the bottom. 11 in. tall.

Bibliography

THIS IS A LIST of books and magazines that are used as resources and inspiration by the artists included in this book. In addition to the specific titles, many artists cited the following general topics as resources: beads, biology, color, folk art, illustrated children's books, jewelry, masks, mythology, nature, ornamentation, pattern, quilting, and textile design.

Books

Albers, Josef. *Interaction of Color.* New Haven, Connecticut: Yale University Press, 1963.

Allen, Jeanne. *Designer's Guide to Japanese Patterns.* San Francisco: Chronical Books, 1988.

Boulet, Susan. Shaman: *The Paintings of Susan Seddon Boulet.* San Francisco: Pomegranate Artbooks, 1989.

Bruce, Beck. *Produce, A Fruit and Vegetable Lover's Guide.* New York: Friendly Press, 1984.

Bridaham, Lester Burbank. *Gargoyles, Chimeras, and the Grotesques in French Gothic Sculpture.* New York: Da Capo Press, 1969.

Carroll, Lewis. *Alice in Wonderland and Through the Looking Glass.* Chicago: World Book, 1988.

Corredor-Matheos, Jose. *Tamayo.* New York: Rizzoli, 1987.

Dale, Julie Schafler. *Art to Wear.* New York: Abbeville Press, 1986.

Davis, Courtney. *The Celtic Art Source Book.* London: New York: Blandford Press, 1988.

Dubin, Lois Sherr. *History of The Beads.* New York: H. N. Abrams, 1987.

Epstein, Diana. *Buttons.* New York: H. N. Abrams, 1991.

Fassett, Kaffe. *Glorious Color.* New York: Potter, 1988.

Fellman, Sandi. *The Japanese Tattoo.* New York: Abbeville Press, 1986.

Fisher, Angela. *Africa Adorned.* New York: Abrams, 1984.

Fitch, Janet. *The Art and Craft of Jewelry.* New York: Grove Press, 1992.

Froud, Brian. *The World of the Dark Crystal.* New York: Henson Organizations Pub., 1982.

Ginn, Victoria. *The Spirited Earth.: Dance, Myth, and the Ritual from South Asia to the South Pacific.* New York: Rizzoli, 1990.

Pod Bracelet. *Pier Voulkos.* (Photograph by George Post.)

Godwin, Malcolm. *Angels: An Endangered Species.* New York: Simon and Schuster, 1990.

Kuboto, Itchiku. *Opulence: The Kimonos and Robes of Itchiku Kubota.* Tokyo; New York: Kodansha International, 1984.

Itten, Johannes. *The Elements of Color.* New York: Van Nostrand Reinhold Co., 1976.

Jacobs, Jillian. *The Nagas: The Hill Peoples of Northeast India: Society, Culture, and the Colonial Encounter.* New York: Thames and Hudson, 1990.

Johnson, Buffie. *Lady of the Beasts: Ancient Images of the Goddess and Her Sacred Animals.* San Francisco: Harper & Row, 1988.

Jones, Owen. *The Grammer of Ornament.* New York: Portland House, 1986.

Kinsey, Robert O. *Ojime: The Magical Jewels of Japan.* New York: H. N. Abrams, 1991.

Lincoln, Louise. *Assemblages of Spirits.* New York: G. Braziller, in association with the Minneapolis Institute of Arts, 1987.

Lippard, Lucy R. *Overlay: Contemporary Art and the Art of Prehistory.* New York: Pantheon Books, 1983.

Margetts, Martina. *Interanational Crafts.* London: Thames and Hudson, 1991.

Meilach, Dona Z. *Ethnic Jewelry: Design and Inspiration for collectors and Craftsmen.* New York: Crown Publishers, 1981.

Picard, John. *Beads From the West African Trade.* Carmel, Calif.: Picard African Imports, 1988.

Racinet, Albert. *Historical Encyclopedia of Costumes.* New York: Facts on File, 1988.

Richards, M.C. *Centering in Pottery, Poetry, and the Person.* Middletown, Conn.: Wesleyan University Press, 1989.

Roche, Nan. *The New Clay.* Rockville, Maryland: Flower Valley Press, 1991.

Rollo, May. *The Courage to Create.* New York: Norton, 1975.

Schaafsma, Polly. *Rock Art in New Mexico.* Sante Fe, NM: Museum of New Mexico Press, 1992.

Tanaka, Ikko. *Japan Color.* San Francisco: Chronicle Books, 1982.

Truitt, Anne. *Turn: The Journal of an Artist.* New York: Pantheon Books, 1987.

Truitt, Anne. *Daybook: The Journal of an Artist.* New York: Penguin Books, 1984.

Yeats, W. B. *The Collected Poems of W. B. Yeats.* Franklin Center, Pa.: Franklin Library, 1979.

Magazines
Contemporary Doll
Doll Crafter
Ornament

Detail of Village Women Necklace. *Kathleen Dustin.* Village Women Necklace on page 21. (Photograph by George Post.